JOURNEYMAN

THE ART OF CHRIS MOORE

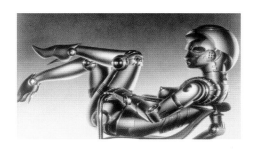

STEPHEN GALLAGHER

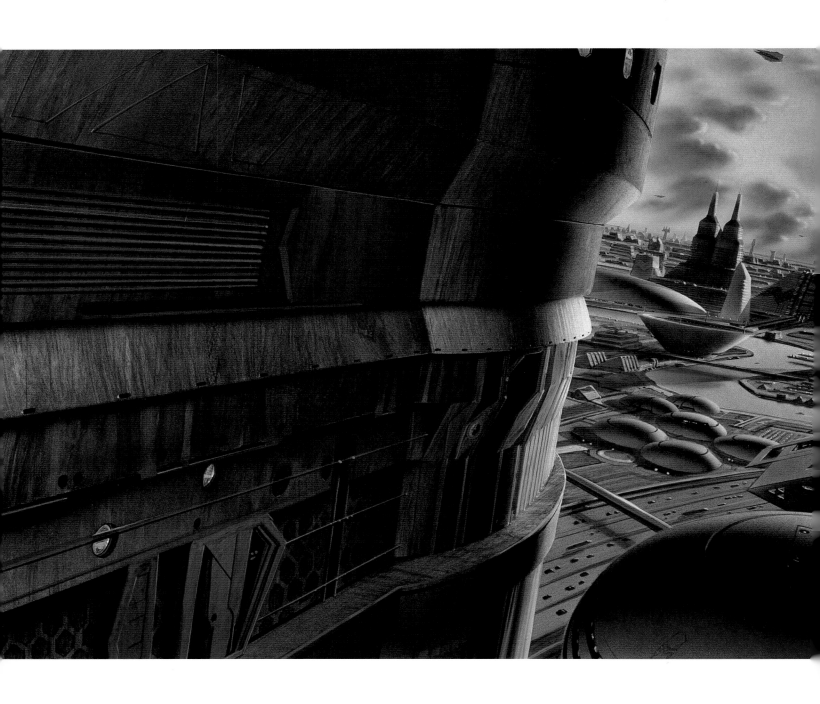

JOURNEYMAN

THE ART OF CHRIS MOORE

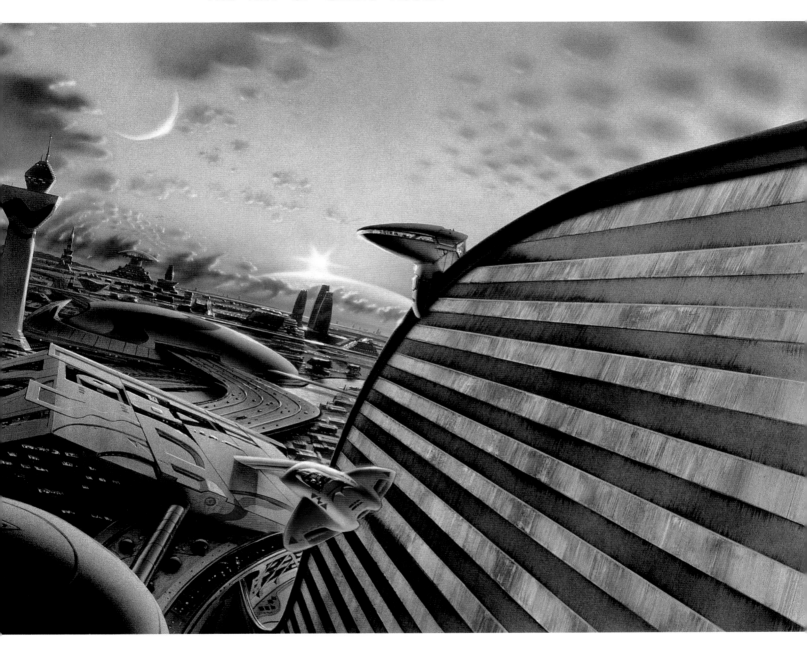

STEPHEN GALLAGHER

First published in Great Britain in 2000
by Collins & Brown Limited
London House
Great Eastern Wharf
Parkgate Road
London SW11 4NQ

Distributed in the United States and Canada by Sterling Publishing Co.,
387 Park Avenue South, New York, NY 10016, USA

1 3 5 7 9 8 6 4 2

British Library Cataloguing-in-Publication Data:
A catalogue record for this book
is available from the British Library.

ISBN 1 85585 849 5

Editor: Paul Barnett
Design: Peter Bennet

Reproduction by Global Colour Ltd, Malaysia
Printed by Sing Cheong Printing Co. Ltd, Hong Kong

CONTENTS

Half title page:
Capitol
*Inks on Oram & Robinson
line board
16x19ins (40x48cms)
Hamlyn Books
Book cover 1980
In the collection of J.B. Rund*

Title page:
New Legends
*Edited by Greg Bear
Acrylic on Crescent board
34.5x15.5ins (88x38cms)
Century Hutchinson
Wraparound plus flaps for a
selected short story
publication 1995
In the collection of Howard
and Jane Frank*

Right:
**The Game Players
of Titan**
*Philip K. Dick
Acrylics on Crescent board
10x15ins (26x38cms)
Harper Collins
Paperback cover 1988
In the collection of
Keith Marsland*

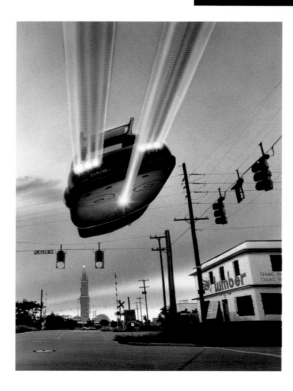

he title needs some explanation.

If there's a streak of vanity any-
where in Chris Moore, I've yet to find
it. And, as you'll see from the long
conversation that forms the main text of
this book, I did my best to dig for one.

What I found instead was a level of
self-deprecation that can be almost maddening at times.
Chris Moore regards himself as a craftsman, a problem-
solver, a supplier of imaginative product for others' needs.
Absent is any trace of the diva, of the prima donna, the
self-publicist, the sense that here is someone who is the
founder and foremost member of his own fan club. There
are practitioners in his field who are like that, believe me.
You sometimes get to touch their robes as they sweep by
you at conventions, campaigning loudly for the awards
they know they deserve, basking in applause like the
ancient emperors of Rome.

You're more likely to find Chris hanging out in the
art room or the convention bar with the likes of Keith
Marsland or Jim Burns or Fred Gambino, close friends
and contemporaries whose
work he openly admires
and with whom he shares
some qualities of style.

INTRODUCTION

The admiration is unforced, unfaked. I've known him go
to a convention with paintings to sell and to come back,
out of pocket, with an armload of other people's work.

Call him a master, or a titan in his sphere, and he
simply won't have it. The most you'll ever get out of
him is a grudging admission of some quiet satisfaction
when something in a picture comes right. I can remember
a slide show of his work that he gave for the local sf
group, back when he'd only recently moved into the area
and few of us knew very much about him or what he'd
done. It had taken some arm-twisting to get him to give
the show at all, as he'd doubted that people would be
interested and was afraid we'd all be bored.

They'd let us take over part of an Italian restaurant
in one of the back streets of Preston. We in the audience
sat there with jaws dropped to the floor as one amazing
image followed another. For many of us there was a
personal angle as we recognized cover art from the very
editions of classic sf novels that we'd read and owned.
You could hear the whispering. I've got that. I had that.
I didn't know he'd done that . . . It was an evening with
a memorable buzz about it, a palpable excitement.

Chris, meanwhile, was working the clicker and
gloomily pointing out the shortcomings of every picture
as it came up. 'This one . . . I never quite got the
expression I was after . . . they wanted this and I
wanted that . . .' Afterwards he asked me, 'Did I go
on too long? Do you think they found it interesting?'

You see what I mean about the maddening part?

In mitigation, I'll say that even when he's being gloomy he's still the funniest gloomy bloke I know, and I reckon that the entire source of his refusal to give in to self-satisfaction is his feeling that, no matter how good the work gets, there's always the possibility that a little more effort might close the gap on perfection. 'I'm never a hundred per cent satisfied with anything,' he says. He's harder on himself than any critic could be, and not because he's trying to impress you with his humility. It's a very private process, and one that perhaps only another artist could fully understand.

Fortunately, the work doesn't need its creator to explain or promote it. It stands up spectacularly on its own. Which is just as well, since my own experience has been that sometimes the only way to get Chris to concede that his work has real value is to get him cornered like a rat in a trap.

And even then it's not easy. His description of himself at the time when he landed a coveted place on a Masters Degree course at the Royal College of Art? 'A slow learner with a modicum of talent.' How did he get in? 'They needed someone for the football team.' The success of the design group that he co-founded in London in the early 'seventies? 'A lot of the work was stuff that I felt that I'd got as a result of being fairly local.'

Which brings us to the title.

Since *Slow Learner with a Modicum of Talent: The Art of Chris Moore* was never really on the cards, we had to come up with something else. We batted a few things around, but it didn't take long to arrive at a notion that seemed to fit . . . a simple term, with more than one edge to it. According to the dictionary definition, a journeyman was a craftsman who worked to order and was paid by the day: a competent worker, qualified to practise his trade in the employment of another. As you'll see, that isn't a million miles from Chris Moore's attitude to his own place in the great scheme of things. At the heart of it, he reckons he does jobs for other people. He solves their problems. He tries to do each job as well as it can possibly be done. Then he passes on to the next.

Those journeyman craftsmen did exactly the same. They worked to order. Their work stood entirely on its merits, and more often than not went unsigned. The pride that they took in their labours was a matter of personal satisfaction rather than any public honour.

Yet in their wake they left us cathedrals, castles, the English landscape and all manner of vernacular architecture. Their mark is wherever we look. They created our entire language of style.

A journeyman, in my opinion, is no mean thing to be.

In this case, it means art without the bullshit.

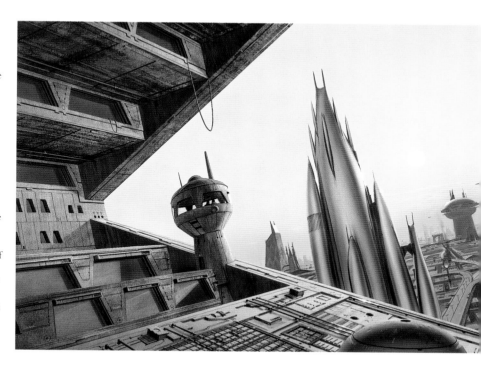

Above:
The Three Stigmata of Palmer Eldridge
Philip K. Dick
Acrylics on Crescent board
21x15ins (53x38cms)
Harper Collins
Wraparound paperback cover
1989

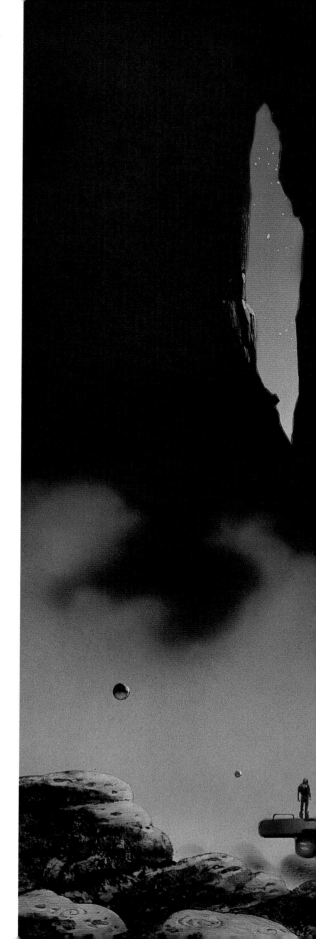

I t's about 8.30 on a cold February night, but I'm in a warm car heading into the moonlit heathlands of East Lancashire.

This is rough and rolling country, up in the northwest of England. The prettier Dales lie to the east and the more spectacular Lake District is barely an hour's drive to the north, so this tends to be an overlooked corner of the British countryside. There are very few big, touristy features to anchor it in people's minds. Pendle Hill, with its associations of witchcraft, perhaps, but that's about it. It's mainly sheep country, all stone walls and forests and reservoirs, accessed by narrow lanes that run up and down the hills like rollercoaster tracks.

Tonight, every valley is a dive into darkness. Every hill is a climb up into the light of an improbably large moon.

Usually when I head out here it's in daylight, and with the dog in the back of the car. Some of my favourite walking country lies out this way. Back in the sixties, Bryan Forbes shot that edgy black-and-white English classic *Whistle Down the Wind* mainly around these farms and villages. The landscape's still largely the same, but nowadays the barn in which Alan Bates concealed himself is probably an architect-designed conversion with a couple of Range Rovers in the yard.

BREAKING GROUND

I'm heading to meet Chris Moore in a country pub about ten minutes' drive from his home. Although we see each other socially most weeks, our plan tonight is to make time away from the usual crowd in order to talk about his life and his work for the record.

I know he's feeling vaguely apprehensive about this. It sounds like a tall order. But I know from past experience that it's easiest to talk on any subject when you tackle it with as little sense of formality as possible, and, besides, some of the pubs around here are quite gorgeous and I don't need that much of an excuse to seek one out. Tonight's venue is a stone building at the top of a one-street village, located between the church and the post office. Down at the lower end of the main street, where a bridge crosses the stream, Hayley Mills once watched a Salvation Army band as it played on a stretch of bare ground beside the water. These days weekend visitors park on the same piece of land, and watch as their children or grandchildren feed the village's ducks. But it's midweek now, so it's quiet. The lights in the bar are warm and low, there's a log fire burning, and right now we can choose any seat in the place. Maybe it'll get noisy later but for now, this is perfect.

Right:
Blindfold
Kevin J. Anderson
Acrylic on Crescent board
20x15ins (51x38cms)
Harper Collins
Wraparound paperback cover
1998

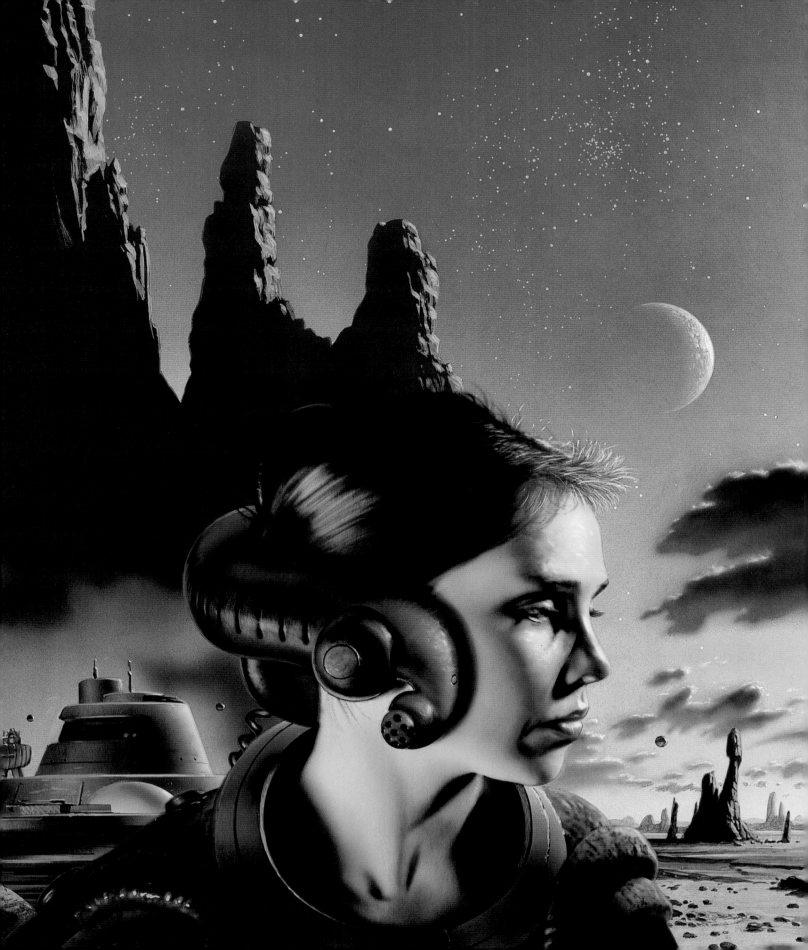

What do I know to begin with? Chris Moore is in his early fifties, and has two tall and good-looking grown-up sons from a first marriage. Now remarried and with a young family, he sometimes seems a little dazed by his luck in the way that this phase of his life has worked out. His wife Katie is a consultant anaesthetist working in the area's main hospital. In Chris's words:

'Professionally she's fast, fun to work with, very efficient, and she's got a virtually one hundred per cent track record in administering anaesthetics. She was a registrar in Manchester when we met and she was set to go to Ann Arbor in the States, near Chicago, as an elective part of her consultancy training, but she abandoned that to go down to Brighton to live with me. She was always a favourite of her professor in Manchester, Professor Healey. He's always stayed in touch with her, and figured that she should have gone for a major anaesthetics post in one of the large teaching hospitals.'

They were married in 1987 after first meeting in Lindos, on the island of Rhodes (a fact that I discovered when I remarked upon some of his Greek-island watercolour sketches, which he'd framed and hung in – of all places – the downstairs toilet). Their two young children attend the village school, where Chris is a governor. He works from a purpose-designed studio over the garage; the house alongside which it stands is stone-built and extensive, and is surrounded by several acres of land. At a barbecue last summer, the house and grounds comfortably absorbed over two hundred people, a large marquee and a bouncy castle. The marquee was the venue for a performance by The Cheating Hearts, the band in which Chris plays guitar.

(The evening of that barbecue grew cold as it got later, catching many people out. The afternoon had been sunny and most had dressed for the warm weather. Our host disappeared upstairs and came down with what appeared to be every old pullover he'd ever owned, handing them out to anyone who was shivering. By the end of the evening it looked like a gathering of some weird Chris Moore Appreciation Society where the acolytes all dressed up in the chunky knits favoured by their bearded hero . . .)

So, here we are. Knowing he's wary of the process we're about to embark on, I decide to kick off with something unexpected.

 How long have you been in a band?

This one?

Any band. What was the first one you were in?

It was called The Black Jacks. I was fifteen or sixteen, and we drew straws to decide who was going to do what. I drew the short straw, so I became the vocalist. The other guys went out and bought cheap Rosetti guitars, apart from one bloke who had a Hofner Verithin. That was a wonderful instrument, except he nearly electrocuted himself at a garden party we were playing at. The thing suddenly became live and he had to drop it. We didn't have a PA system, but my dad paid for an echo chamber and a microphone and I copied the way that Cliff Richard sang.

What year would this have been?

1962.

So this was just pre-Beatles.

Oh, yes. It was Cliff and the Shadows and Elvis Presley and Bill Haley, and I think Adam Faith had just come on the scene. There were bands like the Ventures and Sounds Incorporated, with Little Richard and Gene Vincent and Johnny Kidd and the Pirates. The Hollies were around as well.

Whereabouts was this?

South Yorkshire.

What kind of place did you grow up in? Was it a small town or a village?

It was a small industrial town in South Yorkshire called Swinton, near Mexborough. It was a mining town, and I lived on the edge of it. Similar sort of situation to that film, Kes. That was made in Barnsley, wasn't it? It was very much like that when I was a kid, except I didn't have a kestrel; we just had a mongrel dog. We were about ten miles from Doncaster, eight miles from Rotherham, and nine miles from Barnsley. Sort of in the middle.

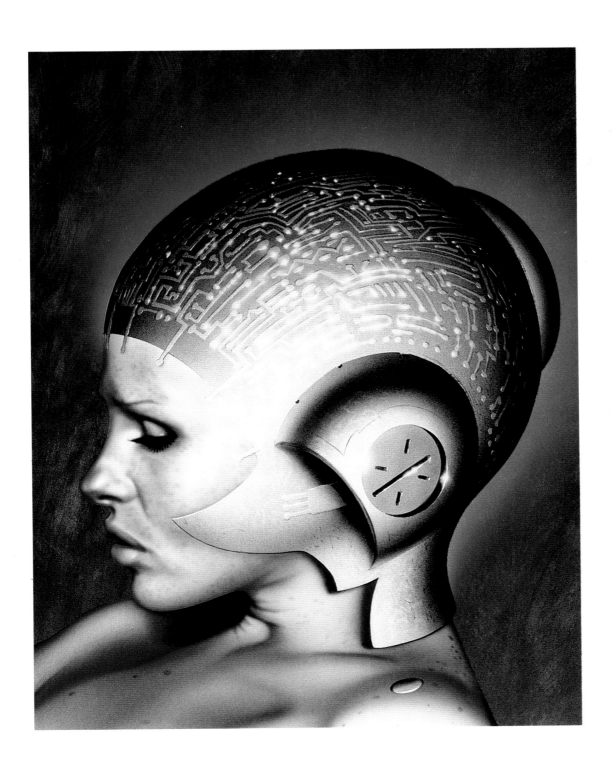

Left:
Burning Chrome
William Gibson
Inks and Acrylic on
CS10 Line board
9x14 ins (23x35cms)
Grafton Books
Paperback cover 1986

> **Requiem**
> This is a completely
> fictitious Scottish
> landscape with the
> exception of the
> rounded peak in the
> distance on the right,
> which is a depiction
> of an actual moun-
> tain on the west
> coast of Scotland.
> When I took a print
> of it to be framed in
> a shop in Edinburgh,
> the woman behind
> the counter took one
> look and said, 'Och,
> it's Suilven!' And
> then she got really
> confused because she
> couldn't place any of
> the rest of it.

Top:
Requiem
Claire Francis
Acrylics on Crescent board
24x16ins (61x41cms)
Macmillan Books
Hardback cover 1986

Above right:
Angels
Denis Johnson
9x9 ins (23x23cms)
Acrylic on Cresent board
Random House/Vintage Press
Paperback cover 1986

What was your dad doing? Was he anything to do with
the mines?

No, no. He was a salesman. At that time he was
selling tea for Lyons, and then he started to work
for the Danish Bacon Company. Later on he
became a representative for a firm of importers.
He sold dairy produce to wholesale outlets. He
was quite successful at it.

Did he have any artistic urges of his own?

When he left school, he was due to start as an
apprentice with a firm of draughtsmen on the
following Monday. But my grandfather wouldn't
let him. He said, 'I've got a job for you down
at the Co-op.' So he left school on the Friday
afternoon and started working in the local
Co-operative store on Saturday morning.
My mum was quite artistic. My mum used
to do lots of embroidery. She was always
quite artistic at school.

So when did you first show what, for want of a better
word, we'll call 'artistic leanings'?

Very, very early. I used to draw aeroplanes and
cars and all that sort of stuff as a small child, and
I can remember what I said to somebody when
they asked me what I wanted to be when I grew
up. I couldn't have been much more than four or
five years old, and I said that I wanted to be a
commercial artist.

Not just an artist, but a commercial artist?

A commercial artist, yes, and that's always stuck
in my mind. Producing what somebody wants.
It's almost as though I was looking for that pat
on the back from the beginning, that seal of
approval from people.

What's the earliest piece of work you can remember
being proud of?

I don't know. It's not that long ago, actually! I
probably handed it in about three weeks ago!

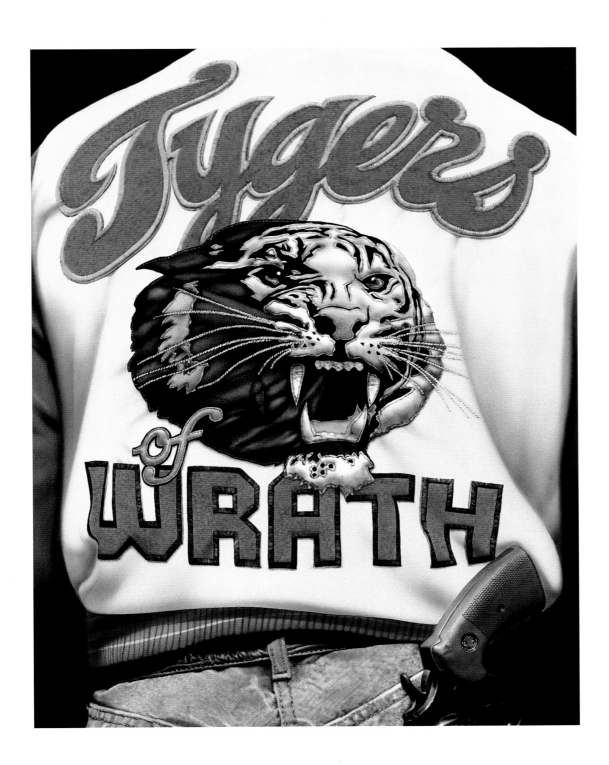

Left:
Tygers of Wrath
Philip Rosenberg
Acrylic on Crescent Board
9x14ins (23x35cms)
Penguin Books
Paperback cover 1991

I'm just wondering if there was ever any point at which you did something and looked at it, and thought, 'I've made a breakthrough here. Before this I didn't quite know what I was doing, whereas now I do.'

But I don't know exactly what I'm doing, even now. I've never felt that. I don't think artists do. It's much more of a solitary, searching process, really.

You've got a very precise command of technique, though, so there must be a point beyond which you can start taking your technical ability for granted and the real question becomes what you choose to express with it. Like when a pianist stops worrying about getting the notes right and concentrates on playing the music.

I see it as like building a brick wall. You get an overall picture of what you think it's going to look like, and with that image in your mind you work through it to get to the end result. And you can go any of a number of different ways. I suppose there have been various points in my technical development where I've found some-thing that works and I think, yes, I can do that again. Like I used to use typewriter rubbers a lot, because the way I work is with a thin film of paint on a smooth board, so you can actually rub away the paint to get a highlight. Sometimes I'll use a scalpel to do it.

What happened when you finished school? Was there any attempt to steer you towards a regular career or was it always going to be art?

Early on, my father suggested, because I wasn't academically very bright at school, that perhaps I could go into the army. That had been his career, up to and during the war. He suggested that either the army or the police force might be good for me. Maybe he subconsciously thought I needed some kind of discipline. I can't say I felt the same way.

Self-discipline, or external discipline?

Well, I certainly wasn't self-disciplined! I'm not saying that my dad was a disciplinarian, because he wasn't particularly, but he wasn't easy-going. He and I had lots of battles.

**As the
Crow Flies**
'I was told the author, Jeffrey Archer, was pleased with the artwork and it was tactfully suggested to me that I might let him have it. Being an old softie, I said all right. He wrote me a nice letter and I understand it's now hanging on his wall.'

Above:
As the Crow Flies
Jeffrey Archer
Acrylics on
Schoeleshammer board
17.5x15ins (44x38cms)
Harper Collins
Paperback cover 1988
In the collection of
Jeffery Archer

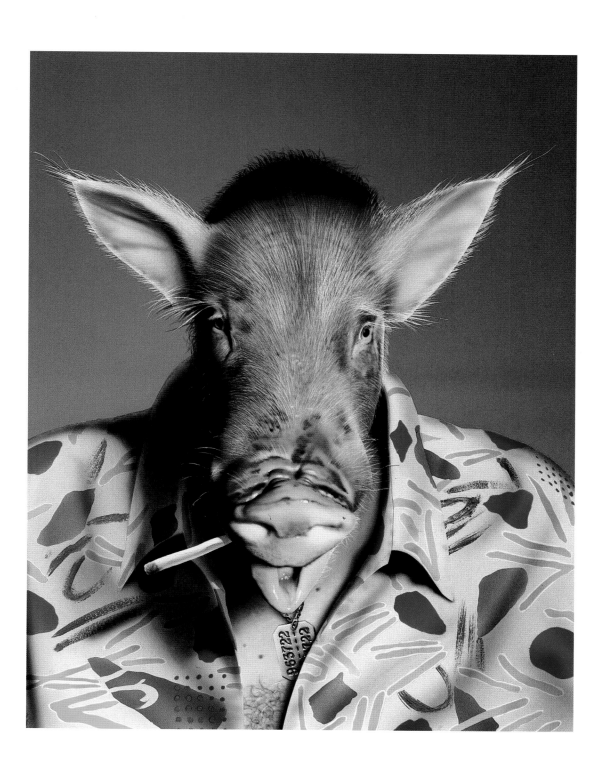

The Therapy of Avram Blok
Because the action takes place in an Israeli mental home the original painting had a Star of David on the chain instead of the dogtag, and the pig was smoking a splif. In view of the shading on the top of the pigs head resembling a skull cap, the publishers asked me to make changes for fear of offending the Jewish community.

Left:
The Therapy of Avram Blok
Simon Louvish
9x14ins (53x23cms)
Acrylic on Cresent board
Corgi Books
Paperback cover 1984

The Broken Bubble
This was an interesting departure because the book isn't really an sf novel, even though it was published as such and the brief was for a science-fictional treatment. I must have been successful with it to some degree, because the art director bought the original artwork!

Right:
The Broken Bubble
Philip K. Dick
Acrylic on Crescent board
9x14ins (23x35cms)
Grafton Books
Paperback cover 1984

Was going to art school one of the issues, or was that a fairly easy choice to make?

When it came to it, my parents certainly didn't discourage me. They let me try for whatever I wanted to do. I'd been good at art and I got a lot of support from the art teacher, but I couldn't get into a major art school. I had to go to Doncaster School of Art, which was a sort of local art school in town. It wasn't a college at all. I went there for a year, and then I applied to three further art colleges to do a diploma course.

What kind of things were you doing?

Just drawing, really, and messing around with graphic and paint, doing linocutting, lots of lithographs. And I can remember playing a lot of table tennis.

Was it all practical, or was there any art history?

Yes, there was art history. I don't remember that much about it. I do remember that there were one or two very strange people on the course. There was a guy called George, and he wasn't actually part of the college at all, but he used to hang around in the canteen, doing these paintings. He'd stretch a piece of watercolour paper on a board and sit there painting these melting buses and things, like a Salvador Dali type of character.

Doncaster buses?

That's right, yes, these red buses, sort of dripping and melting across the road. They were very good in a funny sort of way, but he wasn't anything to do with the college at all.

Was there any kind of artistic bohemian life that centred around the college?

No, you didn't get much of that in Doncaster. Maidstone was different. There was quite a lot going on there, and the art school – it was . . .

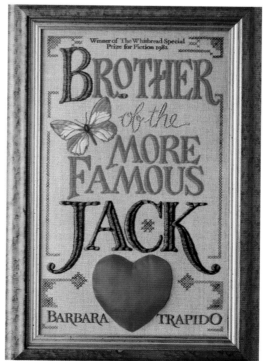

Above:
Beloved
Toni Morrison
Acrylics on Crescent board
10x15ins (25x38cms)
Vintage Press
Paperback cover 1998

Left:
Brother of the More Famous Jack
Barbara Trapido
Gouache on Acetate
12x18ins (30x46cms)
Black Swan/Corgi Books
Fake embroidery 1983

So how did you get from Doncaster to Maidstone?

I applied to do a diploma course, which was three years giving you a BA in graphics, or whatever it was. That was very good, it was very informative. I mean, I knew that I wanted to be an illustrator, and most of the guys lecturing and running the course were illustrators themselves. Gerald Rose was one of them. He was a big influence.

What was the status of illustration then? Because there have been periods when illustration has been frowned upon in the art schools.

Illustration was largely confined to children's books, from what I can remember. There didn't seem to be very much in the way of book jackets and advertising work around at that time.

What future did you see for yourself? Did you see yourself becoming a children's book illustrator?

I don't know. I mean, I dabbled in kids' books, did a few test runs and things like that, but I just knew somehow – I mean, I remember you telling me that you just knew that you were going to be a writer. It was the same kind of feeling. I just knew what I wanted to do, and that somehow I was going to make a living from it. There was never any doubting it.

What was the big difference between Maidstone and Doncaster, then? Was it wider horizons or better teaching, or was the difference in you?

It was a matter of development. As you gained confidence you realized that the people who were teaching you weren't infallible. You'd see flaws in them, and you'd gradually realize that in fact they weren't that much different from you. Your point of view was as valid as anyone's, if you could find the means to express it. It was just a gradual process.

Left:
A Scanner Darkly
Phillip K. Dick
Acrylic on Cresent board
23x14ins (58x35cms)
Harper Collins
Paperback cover 1992

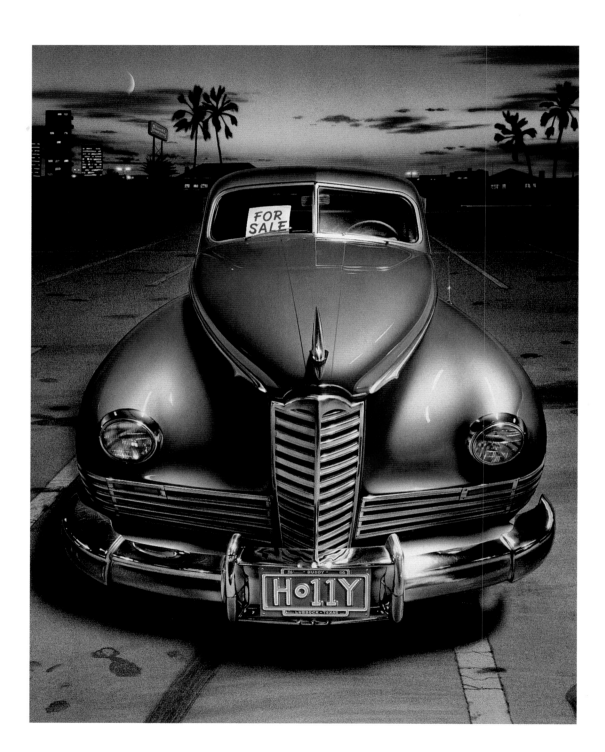

So how old were you at this point?

I started when I was eighteen, and left when I was 21.

Where did you go on to?

I went to the Royal College, for another three years, to do a Masters Degree. For a slow learner like me, it was ideal. You're thrown in with a bunch of other people who are all similarly inclined, who all have a modicum of talent, and you bounce off each other all the time, spark each other off.

You refer to being a slow learner and having a modicum of talent. But the Royal College of Art is no minor institution. It's no mean achievement to get onto a Masters Degree course there.

I came to the firm conclusion that the only reason I got in was because I went on a bit about football, and they needed somebody for the football team! There were people who I thought were a lot better than me who didn't get in. When I went for interview there were around 30 people going after ten or twelve places. And I can remember, we were set a test where we had to paint something, and I think I had to do my view of an earthly paradise, and I just did a garden with loads of flowers and things. Very imaginative! And I thought, Jesus, I've blown this, I don't stand a cat in Hell's chance. There were other people doing these very introspective pieces . . .

And one guy in a corner doing melting buses?

No, I didn't see George there! But when they made their final selection they chose a very mixed bag of people.

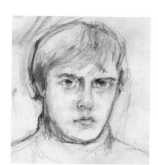

Top right:
Self Portrait
A4
College work 1967

Top left:
Sister Portrait
Pencil on cartridge paper
8x8ins (20x20cms)
This was a sketch of a
fictitious sister (I am an only
child) which bears a close
resemblance to my daughter
Georgia would you believe?
College work 1968

Left:
The Bluest Eye
Toni Morrison
Acrylic on Crescent board
9x14ins (23x36cms)
Penguin Books
Paperback cover 1998

And was there any kind of specific purpose to the course? Was it shaped with a certain agenda in mind?

If there was an agenda, I think it was to work with people who were not yet completely formed in terms of what they wanted to do. People who were still malleable to a certain extent, whether by the staff or by their own influences or whatever. I was pretty much like that. What I eventually ended up doing bears no relation to anything that I ever did before it. If you look at things that I did when I was at college at Maidstone, you'll see all these Hogarth-inspired buildings leaning over and things like that. I'm very eclectic. I see things and I think, 'That looks good, I'll use that.' I'm really careful looking at other people's work because I do tend to pinch things.

Were you going to galleries? What kind of stuff influenced you?

My main influences at that time were American illustrators like Bernie Fuchs and Bob Peak. They had this kind of slickness in their work. They weren't afraid of the medium, they could splash it about and somehow make something out of it.

Above:
The Day of Forever
J. G. Ballard
9x14ins (23x36cms)
Harper Collins/Paladin
Large format paperback
cover 1989

Right:
Cemetery World
Clifford D. Simak
Inks and Acrylic on Oram
& Robinson line board
22x15ins (56x38cms)
Methuen
Wraparound paperback
cover 1977

Far right:
Beyond Lies the Wub
Philip K. Dick
Acrylic on Crescent board
20x15ins (51x38cms)
Harper Collins
Wraparound cover for
Volume 1 of Philip K.
Dicks short stories 1993

Right and above:
Great Marques
Acrylic on Schoeleshammer
board
10.5x13ins (27x33cms)
Octopus Books
A few of the series of nine
'Great Marques' books
commissioned by Octopus
Books in the early eighties

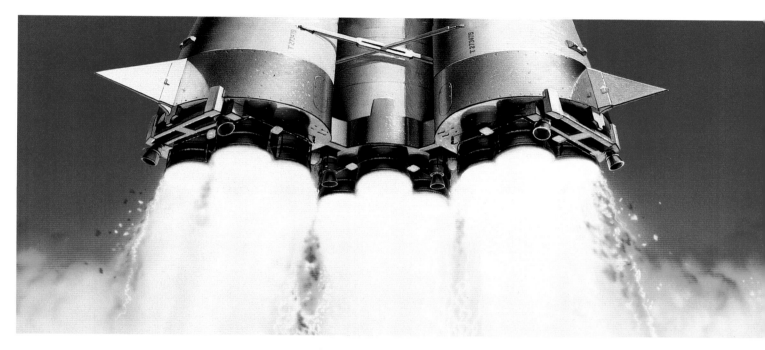

So where did they work? Were they magazine illustrators?

Yes, fashion magazines. Mainly editorial stuff and some advertising as well. But they were the big players, from my point of view. I remember at the Royal College interview they asked me who were my favourite painters, and I said, well, Bob Peak and Toulouse Lautrec, and they just looked at me.

You had quite a good time there, didn't you?

I did, yes, it was really good, it was that great time around the late sixties and early seventies. I got to know an awful lot of people, because I used to organize all the dances and discotheques and things there – I was the Social Secretary – and that was great, because you got to meet everybody. Out of three hundred students I probably knew two-thirds of them by name.

And it was at the Royal College that you first started to work with the airbrush.

There was a friend of mine called Gordon Thompson. He needed help on a project and suggested that – well, in fact, he didn't suggest, he just said, 'You can do airbrush, can't you?'

Above:
Russian Rocket
Acrylic on Crescent board
48 sheet poster for a
New England based
Space Museum 1992

Above:
Point Blank
Ink on CS10
20x30ins (50x76cms)
Film poster for RCA Film
Society 1969

Above right:
Iris
Michael Capobianco
Acrylics on Crescent board
23x17ins (58x43cms)
Wraparound book cover for
Avon Books 1998

Right:
Edge of Honour
Richard Herman
Acrylic on Crescent board
9.5x14ins (24x36cms)
Hodder Headline 1999

Far right:
The Foreigners
James Lovegrove
Acrylic on Crescent board
13.5x21ins (34x53cms)
Orion Books
Hardback cover 1999

So, what did you do?

I found an airbrush at the college, and I asked Dan Fern how to do it. He was in the year above me, and he'd done some airbrushing. He's Professor of Illustration there now. He said, 'Oh, it's easy. You just go and buy this stuff called Frisk Film which you use as a mask, and you sort of spray the colour on.' I tried it and it was like love at first sight. I remember I did a poster for the college film society. They had to produce a poster every week for a film that was going to be shown on Thursday night. I did one for *Point Blank*. Another time I did *The African Queen*.

So really you were doing a kind of advertising project in miniature, weren't you?

Yes. And they'd be printed in the print shop.

Do you still have any of those?

I think I do, yes, somewhere. So anyway, what happened was that as soon as the guys in graphics knew there was somebody in illustration who could use an airbrush, I kept getting all these commissions.

Within the college?

Yes. I became kind of a service industry to the graphics department. A friend of mine, Ray, did a thesis called 'They're Really Rocking in Burslem'. It was about his youth in the Potteries. He had a picture of Burslem town hall on the cover of it, and he wanted to put a gold Cadillac in the street outside and so I airbrushed one in for him. I did quite a few things like that. And when I eventually finished, a lot of the stuff in the graphics degree show was stuff I'd done for people. I had my own show as well. It was quite good grounding.

Did anything come directly of the show?

Well, there were various offers of teaching. One was at Kingston, one was at Maidstone. The Kingston one didn't materialize and the Maidstone one didn't come to anything until about two years after I'd left. By then I'd gone into forming a design group working in London, in Covent Garden, which at that time was a bit of a ghetto for designers and illustrators and photographers.

Right:
A Sickness in the
Soul
Simon Maginn
Acrylic on Crescent board
9x14ins (23x35cms)
Transworld
Paperback cover 1995

So what did you do? Go back to Maidstone as a visiting professional?

I did a couple of weeks a term where I set a project to the students in return for a little money and a lot of hero-worship. Three days a week, six days in all.

What did you think of that?

Teaching as a career didn't interest me that much, to be honest. It's quite good as an ego trip because, having gone through seven years of art school, including time at the Royal College, and then working in the environment that all these kids ultimately want to go into, you've automatically got their interest. So I used to sort of sweep down from London and just impart a bit of knowledge and sit round chatting and drinking coffee and setting a project, and I really had their undivided attention. That was great. The best part was seeing the penny drop with some of them as they realized that art wasn't just about decoration and embellishment: it was all about original thinking.

And in the meantime you'd been setting up this design group in Covent Garden. This was the old Covent Garden?

Yes, some of the market traders' places and ware-houses were becoming vacant as the traders moved out. They had very, very cheap studio space. In fact, a friend of mine had almost the entire basement of the Royal Opera House along one side – James Marsh. He and John Farman had a company called Head Office, and they used to do all those plasticine models for British Airways that you used to see in the seventies.

Plasticine models?

Well, they were sort of caricatures made out of plasticine for advertising, a bit of a forerunner to the TV show *Spitting Image*. They'd do all that sort of stuff.

What part of Covent Garden were you in?

We rented space inside an architect's office which was behind the Lyceum Theatre on the Strand. There was myself, a chap called Michael Morris who did graphics at the Royal College, and another guy called Brian Delaney, who also

Top left:
Chicken with olives and green peppers
Acrylic on canvas board
13x18ins (33x46cms)
Illustration for 'The Artists Art of Cooking', a recipe book featuring favourite dishes of the stars
Phonogram Records 1980

Left:
Cary d'agneau à l'Indienne
Inks, Gouache and Acrylic on Watercolour board
5.5x9ins (14x23cms)
Illustration for 'The Artists Art of Cooking', a recipe book featuring favourite dishes of the stars
This was a lamb curry so I painted it in the style of an Indian Miniature
Phonogram Records 1980

did graphics. Brian went off very shortly and teamed up with somebody called Darryl Ireland, and they became Ireland Delaney, and Michael and I were called Moore Morris. We'd been all through the process of trying to think of zappy names for it, like 'Plugged-In Graphics' or 'Whitewall Designs' or something, and they were all too pretentious. We didn't like pretentious things, so we used our own names.

It was quite an interesting time. For two years I worked in a room with no windows. It had a skylight, but you couldn't see anything out of it. The ground floor of the building was a greasy spoon type of café, Frank's Café, I think. An architect called Ken Burgess and a photographer named Don Cooper had the first floor, which had a tiny conference room.

The address was Wellington Street but the door was on Exeter Street, and we used to get tramps hanging around the back of the Strand Palace Hotel nearby. They used to gather round the big exhaust for the ventilator in the winter, because there'd be warm air coming out of it. On the dark nights, when they wanted to urinate, they'd just shuffle a few yards down the road and piss in our doorway. It would run under the door and soak into this big, fitted doormat that we had in the lobby downstairs. It was horrible. The guy whose place it was used to complain bitterly about it, but we didn't see that there was anything that we could do to stop it happening, save going out there and kicking them when they were doing it! But then Michael and I applied some lateral thinking to this. We just put a light out there, and it cured the problem.

I thought you were going to tell me that you electrified the mat . . .

We thought of that, actually. We were going to run a live wire along the bottom of the door so that when they peed on it they'd get a jolt, but, no, we just put a light outside and the problem stopped.

So what kind of commissions were you existing on at this time? Were you doing advertising, or covers, or what?

Well, we had a connection with a design group called Industrial and Shipping Design, and they had the contract to do editorial work for a magazine called *Sea Trade*. Mick and I used to do a cover for this every month, which was good

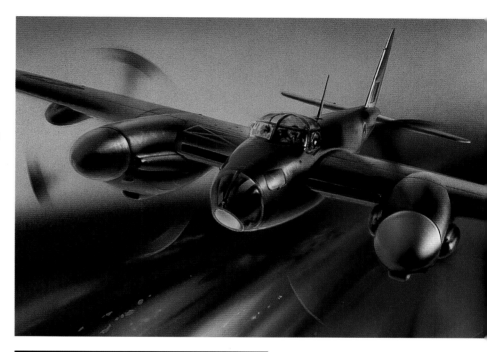

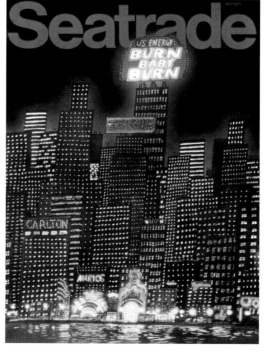

Above:
Mosquito Run
Richard Herman
Acrylic on Crescent board
9.5x14ins (24x36cms)
Hodder Headline
Book cover 1999

Left:
Seatrade cover
Inks and Gouache on
watercolour board
9x12ins (23x31cms)
Seatrade Magazine/
Industrial and Shipping
Design 1973

Far Left:
Delta Connection
Hammond Innes
Acrylic on Crescent board
24x15ins (61x38cms)
Pan Books
Wraparound paperback
cover 1992

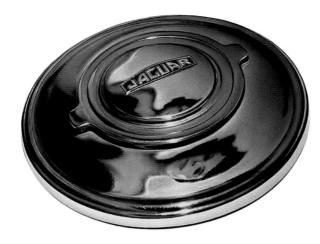

Concrete Island

For me this illustrates the difference between British and American book-jacket requirements. The legs painting was for a US edition, and I suppose you could say it's like a sexy fashion magazine shoot. I did a completely different image for the British edition, involving the reflections in a Jaguar's hubcap. The British approach was more oblique, more subtle. The differences aren't as pronounced now as they used to be.

Top and right:
Concrete Island
J. G. Ballard
Inks and Acrylic on line
board
10x15ins (25x38cms)
Random House / Vintage Press
Paperback cover 1985

Far right:
Golf Club
Acrylics on Schoeleshammer
board
11x17ins (28x43cms)
Advertisment for J. Walter
Thompson
The image was to show a golf
club that had been struck
across the head of an
opponent on the golf course
1988

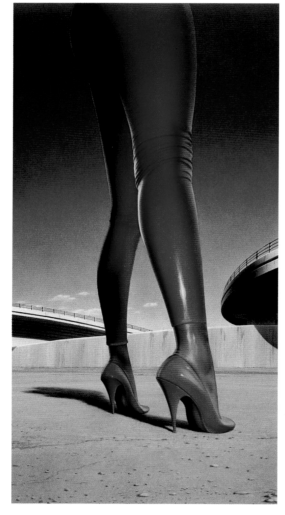

fun. We were open to all sorts of strange ideas, and we had a right laugh with that. We used to put a little bit of something on there. You know how the Playboy covers have always got a little rabbit somewhere? Well, we used to do a little bit of porn every time. Like, on one I had this big picture of a New York skyline with all these millions of windows. It took me days to do it, and in one of them I had this naked couple standing there. You could barely see it. But after that, everybody started looking for the rude stuff. I did a picture of a dripping tap which we hung on the back of the toilet door for any clients in need of help, and there was a reflection in the chrome that could have been something. We used to do a lot of that sort of thing, and we also had one or two commissions.

What was your setup like?

We sort of worked as a team, coming up with concepts, trying to work out ideas for things. Mick was a very good ideas man, very well read, very intelligent chap, and for a long time the way it worked was that I did the pictures and he did the type and the design. We became known as guys who solved problems.

Presumably there wasn't a big capital investment in this. You didn't have to buy a ton of computer equipment and the latest graphics package . . .

No, it was nothing like that: just brushes and paint for me, and Mick bought in typesetting materials as he needed them. That was why we split up in the end, really. My work incurred very little in the way of expenses whereas Michael was buying in photography, buying in type, buying in all that kind of stuff which costs money. So if you take a job which was worth, say, £1,000, and you split it down the middle, £500 for the artwork and £500 for his side of it, you'd find that £300 of his side of it would have gone on expenses whereas my costs were more like £5. So it doesn't take a genius to work out how it becomes unbalanced.

So what kind of life were you living at this time? I mean, was it paying you quite well? What kind of flat did you have? What kind of car were you driving?

I had a Reliant Scimitar. There was a guy named Alan Dempsey working in the same studio who used to do all the lettering for a lot of advertising agencies, and he designed the logo for the back of the Reliant Robin.

So you had the Scimitar, which was this cool fibreglass-bodied coupé, which just happened to be made by the same company that manufactures the most ridiculous three-wheeled car in the world?

That's right. He made up one of the name badges that goes on the back of the Reliant Robin, and he stuck it on the back of my Scimitar. It said 'Super Robin', and I was driving around in this bloody thing and I never noticed. I used to get people grinning as they overtook me. I still get a Christmas card from him every year.

Where were you living then?

It's hard to say. It's all a bit of a blur. I went out with lots of different girls, and had lots of parties, and had a great time really.

Was your artistic sensibility, for want of a better phrase, changing over that time? Was it developing?

Yes, I was becoming attuned to what was required of me. At college you don't really get much practical direction. In fact, the only time you get any professional insight is when you get a visiting tutor in, like I became. Those are guys who are actually doing it, and so you get to hear about dealing with deadlines and all the other realities.

Was there a kind of excitement when somebody like that came in and you glimpsed their world?

Yes, there was.

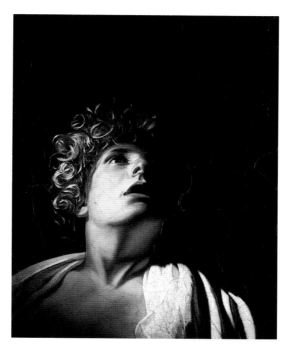

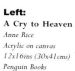

A Cry to Heaven
This is painted in the style of a Caravaggio. My son Will modelled for it when he was about thirteen. He's wearing a blond wig which Katie bought me for my fortieth birthday. She made me wear it in the restaurant...

Left:
A Cry to Heaven
Anne Rice
Acrylic on canvas
12x16ins (30x41cms)
Penguin Books
Paperback cover 1992

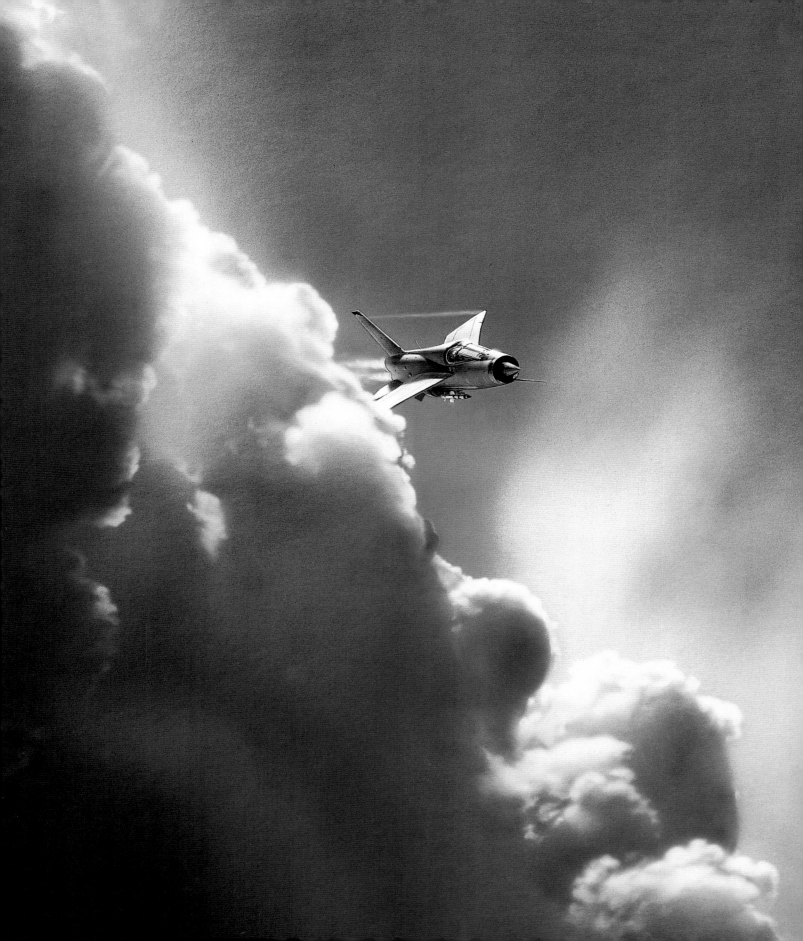

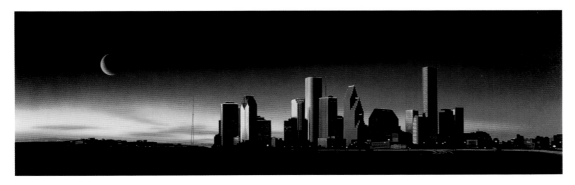

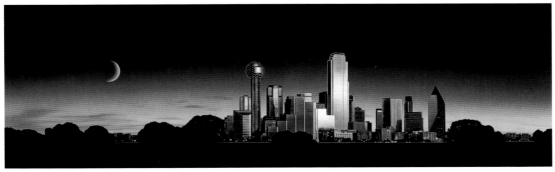

Was there anyone who particularly got you going?

I can think of two. There was Ron Sandford and there was Bob Gill. They were thinkers. We had decorative people like Paul Hogarth and Quentin Blake, who were very admirable in their way, but they didn't deal in content or conceptual stuff. I'm talking about finding ways of expressing an idea through a visual image. A lot of the stuff that was produced in the seventies by Pentagram and some of the other large design groups was that sort of work.

Anyone else?

Derek Aslet, who was Art Director for the men's magazine *Mayfair*, came down once. I later found myself working across the road from him when we were in Covent Garden. I remember he had this dog called Archie, which was like a cross between an Afghan and an Irish Wolfhound. A great big black dog with great floppy ears. It was blind, and it used to sniffle around the studio in this big converted warehouse where the windows ran all the way down to floor level. One beautiful

Above:
Dallas and Houston
Anheuser-Busch
Acrylic on Crescent board
10x30ins (25x76cms)
1995

Far left:
The Trojan Sea
Richard Herman
Acrylic on Crescent board
16x24ins (41x61cms)
Hodder Headline
Hardback dust jacket 2000
The publishers wanted to
extend the sales of this book
to a more feminine readership
as well as the traditional
techno-thriller reader hence
the 'softer' feel

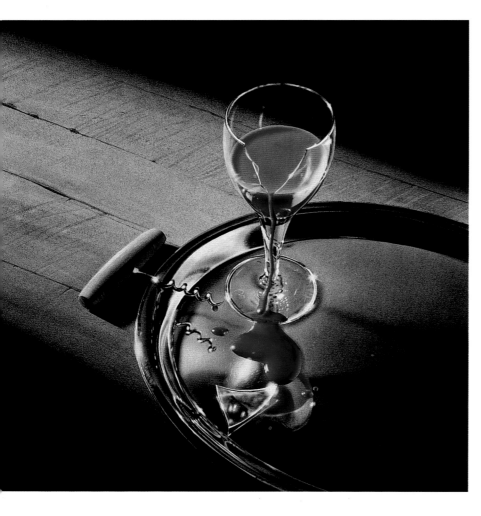

Above:
Above:
Blood is Thicker
Than Beaujolais
Tony Aspler
Acrylic on Crescent board
16x24ins (41x61cms)
Hodder Headline
Book cover 1992

summer's day they were working with all the windows open, and then suddenly somebody said, 'Has anybody seen Archie?' There was a knock on the door almost immediately, and it was the guy from the art gallery on the next floor down. He said, 'Has anybody got a dog?' and everybody immediately went, 'Oh, no!' He said, 'Well, I've just seen it going past my window, and its ears were flying up like this.' Well, everyone was horrified. He said, 'I thought it was a joke. I thought he was going to bounce back.' Poor old Archie was splattered all over the pavement.

It sounds as if you launched into those Covent Garden days and the start of your career without much of a map.

A lot of the people at the Royal College had been confused about whether illustration was actually fine art, or whether it was printmaking, or whatever. But I think I always knew what illustration was to me. It's to use your skills to be able to communicate a simple idea in as effective a way as possible to anybody, irrespective of the language they speak.

That puts me in mind of something that Salman Rushdie once said, which is that he sees himself as an artist whose job it is to make his art and if the reader doesn't get it that's the reader's problem.

I don't agree with that at all. In fact, it's the complete opposite to my own philosophy. If something is obscure and difficult to understand, then that defeats the purpose of it.

It's a failure of communication on the part of the communicator?

I'm quite prepared to accept that people see it as being OK to be esoteric and obscure, but it's not for me. I'm always suspicious when you have people talking about their paintings on television. I'm always very suspicious about the fact that they've got to talk about their paintings in order to justify them or explain them in some way.

Do you still continue to take an interest in what's going on in the — for want of a better word — fine-art world, or do you feel remote from it?

I've never felt part of it, and I feel quite cynical about a lot of it.

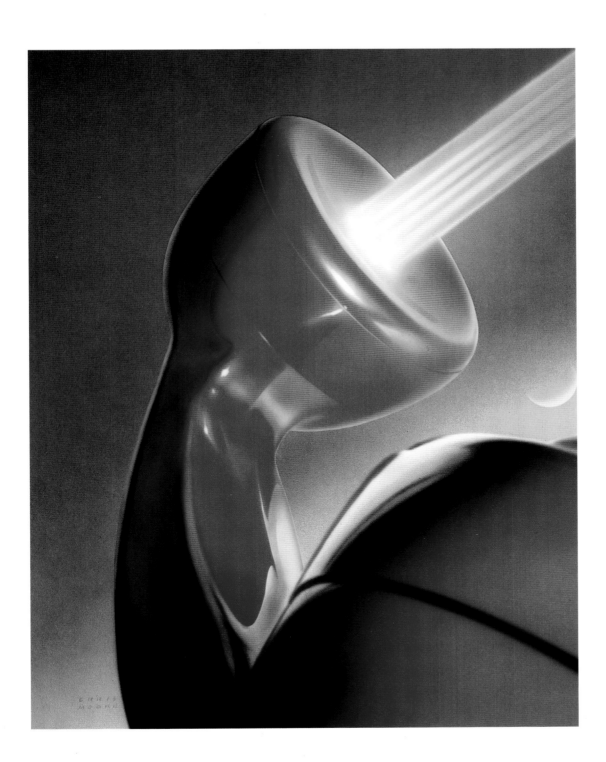

Poster for STC
(Standard Telephones and Cables)

The company was developing a system of fibreoptic telecommunications. They were presenting their proposals in the form of a lecture. They had an idea for their visual presentation but, when they called me in, I wasn't too keen on what they had and countered with the suggestion of this enormous monolithic telephone with a searing light beam coming out of it. I could see their eyes widening at the thought. I quickly scribbled something on a piece of paper to expand on the idea, and they went for it. They changed the entire concept of the lecture — all the publicity, and everything — and they even used the little sketch for the front of the programme. It was a perfect example of how these things should work . . . you have a creative spark, and a sympathetic client who'll just go with it and see it through.

Left:

The Photon Connection

The Faraday Lecture
Acrylic on Crescent board
11x16ins (28x41cms)
Standard Telephones
and Cables 1983

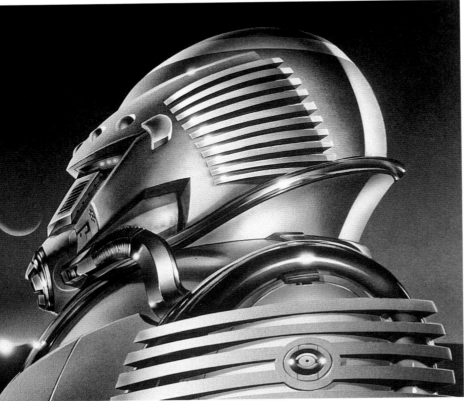

You don't go to the galleries or see the new stuff that's coming out, or . . .

I don't have the time now.

So when did you start to specialize in book covers? Because that's the kind of work that you've become best-known for.

I started back in about – well, I left college in 1972, and I did my first book cover in the same year. It was for Faber, for one of Lawrence Durrell's books.

What was it like? Because I never think of Faber covers as being all that visual.

Not particularly inspiring, I must admit. It was a picture of a whale, a hump-backed whale, for his early novel *The Black Book*. The cover was black – a one-colour cover, I think, perhaps with spot red on the type. The next cover I did for them, for a book which I can't remember the title of, was awful. I hated it. I did it as a black-and-white drawing, and then did an overlay for a colour. I specified green, and they rejected that. They wanted it red. And I said, 'Well, I think it would work better green.' And they said those immortal words that have haunted me down the years: 'Green doesn't sell.' That was quite a disturbing moment for me. I thought, I'm in the wrong game, I'm only two covers down the road, and I'm in the wrong game.

What was the prevailing fashion at the time, then, in book covers?

It was Penguin, Penguin Classics.

You mean, with more of a bias towards a bold graphic design than realistic painting?

There was some scope for painted covers. Chris Foss was turning out science-fiction stuff, and there were, for want of a better term, decorative illustrators, people like Peter Bentley and Bush Holyhead, George Hardie, they were doing stuff. It was a very vibrant time.

When did you feel that you hit your stride, then? Was it with the science-fiction covers?

Above:
Far Out
Damon Knight
Inks on CS10 line board
9x14ins (23x35cms)
Methuen
Book cover 1974

Right:
Extro
Alfred Bester
Inks on CS10 Line board
11.5x18ins (29x46cms)
Methuen
My very first SF cover 1973

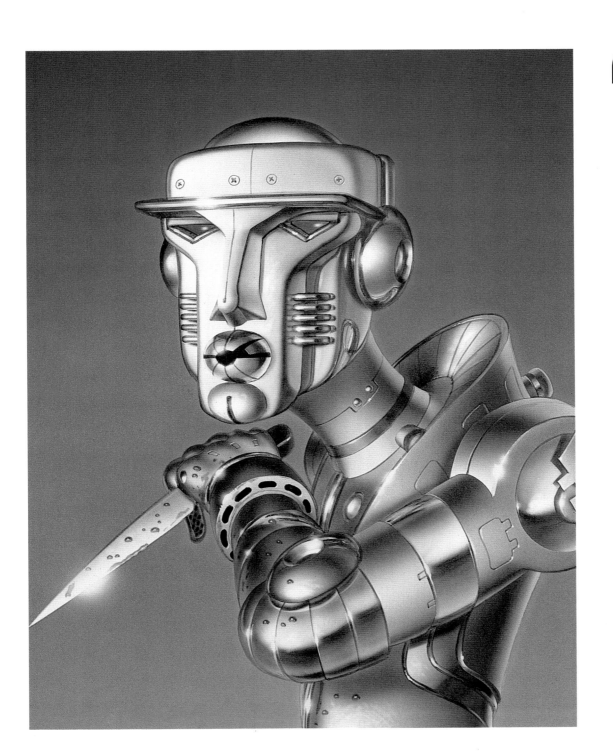

Tik-Tok

"One of my reasons for including this piece of robot art is the resemblance that it bears to the designer of this book in one of his better moods . . ."

Left:
Tik-Tok
John Sladek
Inks on Schoeleshammer
board
10x19ins (26x48cms)
Methuen
Book cover 1983
In the collection of
Peter Bennett

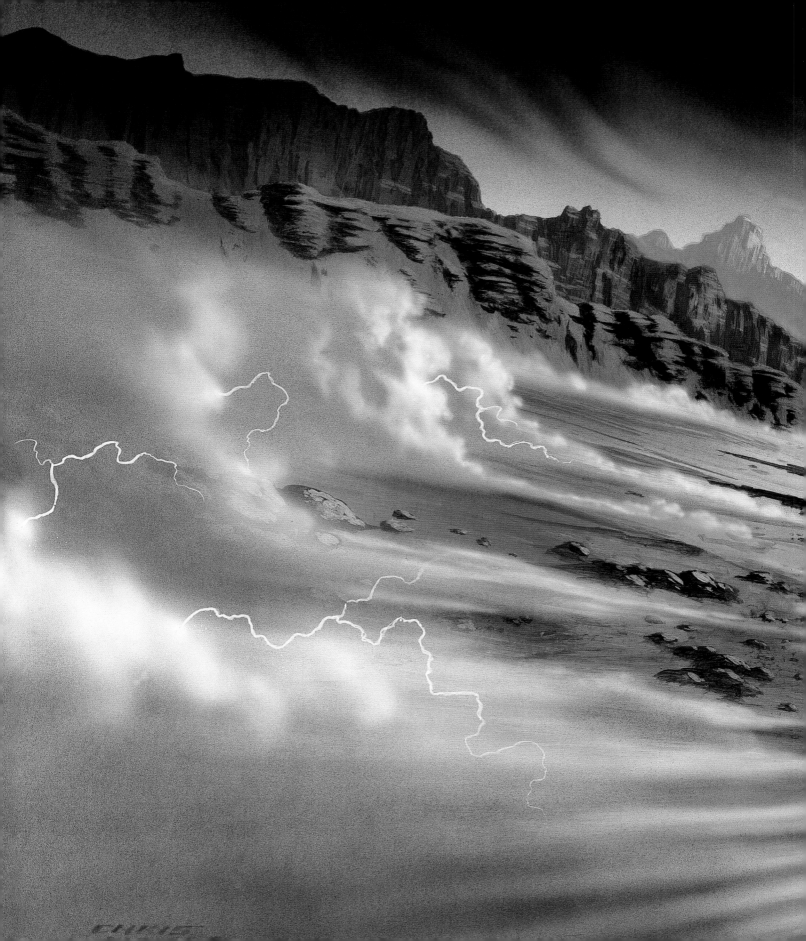

Previous page:
Gardens of the Moon
Steven Erikson
Acrylic on Crescent board
25x17ins (63x43cm)
Transworld
Wraparound paperback
cover 1998
My first ever fantasy
commission

Right:
Babel 17
Samuel R. Delaney
Acrylic on Crescent board
10x16ins (25x41cms)
Orion Books
Bookcover for Masterworks
series 1998

Middle:
Destroying Angel
Richard Paul Russo
Acrylic on Crescent board
9x14ins (23x35cms)
Hodder Headline
Paperback cover 1993

Far Right:
Starmind
Spider and Jeanne Robinson
Acrylic on Crescent board
10x15ins (25x38cms)
Magazine cover for
Analog Magazine 1994

No, not really. That was more of a progression than any kind of a breakthrough. I started doing them because Pete Bennett, who I'd already done several covers for, suddenly said, 'Oh, I think you could do some science-fiction stuff.'

Where was he?

He was at Methuen. He just sort of set me on to it, and that was that. It was a bit of a struggle to start with. In fact, I wasn't aware of science fiction at all. I'd seen *2001*, and that was about it.

How long did the Covent Garden design group last altogether?

Until about 1980, so about eight years. When I got married I moved out of the centre of London.

So where did you move? Did you move into the country?

Yes, near Blackheath. I had a big house in Lewisham, then we moved out to East Sussex, a place called Five Ashes, which is a very nice part of the world.

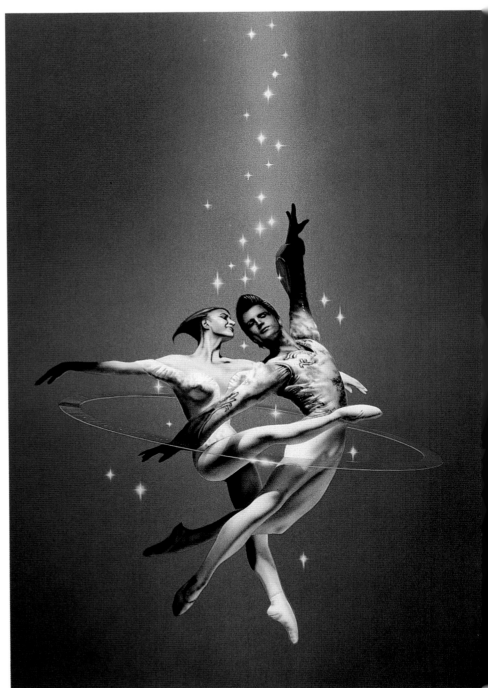

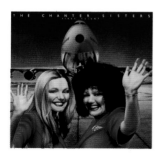

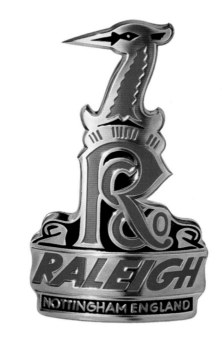

Above:
First Flight: The
Chanter Sisters
Inks on Oram & Robinson
line board
16x16ins (41x41 cms)
Polydor Records
Album sleeve 1976

Above right:
The Disaster Area
J. G. Ballard
Acrylic on Crescent board
9x14ins (23x36cms)
Harper Collins/Paladin
Large format paperback cover
1989

Right:
Raleigh Cycles
Acrylic on Crescent board
7x12ins (18x30cms)
Symbol to be used on all
advertising for the Raleigh
Cycle Company 1985

Far right:
Dark Wing
Richard Herman
Acrylic on Crescent board
9.5x14ins (24x36cms)
Hodder Headline
Book cover 1993

So how did your life go in the eighties, then?

Well, on the career front, moving out of London was quite a big step. A lot of the work that I'd been doing up to that point was stuff that I felt that I'd got as a result of being close to where it was all happening.

Were you not established by that point, though?

In some areas, yes. I'd been doing quite a lot of record covers. I mean, we can touch on that . . .

Yes, let's.

There was this girl group called The Chanter Sisters. They were the backing singers for Roxy Music. Nice girls. I did this illustration for them dressed as air hostesses in pink outfits, standing in front of a bright pink Boeing 747. Then Justin de Villeneuve got involved in it, and their profile immediately went from being 'Well, OK, we'll release your record if you insist' to 'Oh, yes, no expense spared'.

He was still a force at that point, was he?

Justin? Well, he'd been through all the Twiggy stuff and been involved with various other artistes, but I suspect that he went quite sadly awry with this lot. He personally took out every newspaper music journalist for lunch, to try and promote this record, and they had this huge reception at the Café Royal. We did a corporate design for the whole thing.

All based around your original pink-air-hostess painting?

There were the uniforms to be made, banners, stickers – we got all this work to do, it was great. The picture was based on some reference photographs that I'd taken in the reception suite at Polydor Records while they were miming to *Dancing in the Street*. Anyway, Doreen, the blonde-haired one, she came out of it with bags under her eyes, and she was quite upset at this. So she was hot-foot round to my studio with the art-work and sat there while I took them out! And my mum was there. It was a very weird situation, because it wasn't a very big room, and my mum was sitting in the corner on this chair, knitting, while there was this glamorous pop star looking over my shoulder while I retouched the bags out from under her eyes.

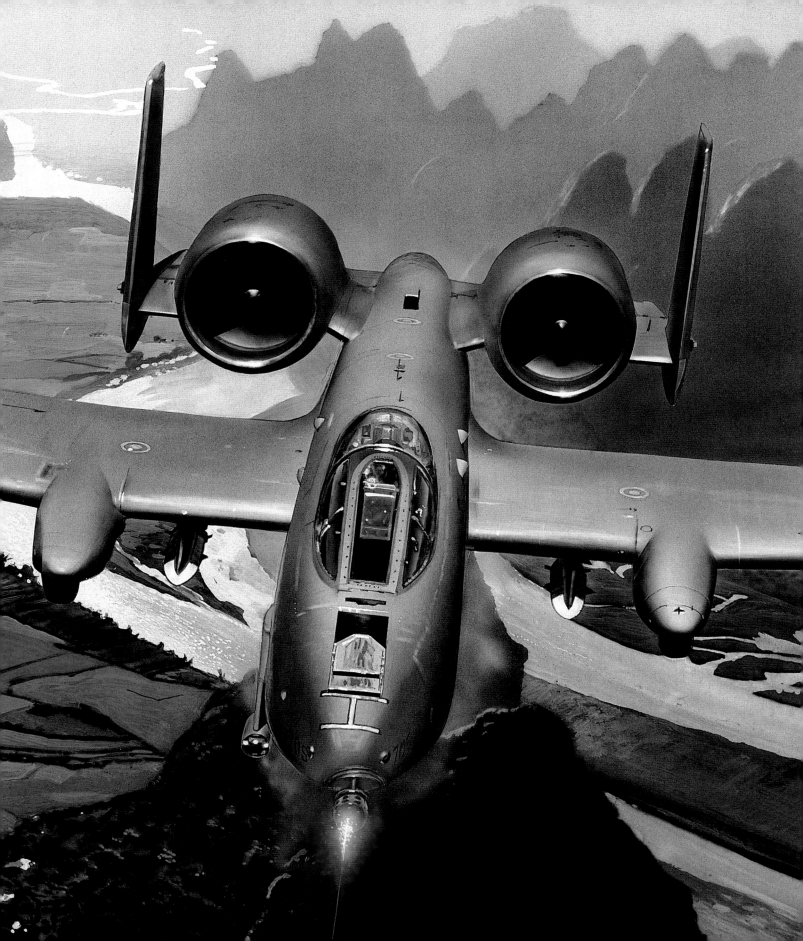

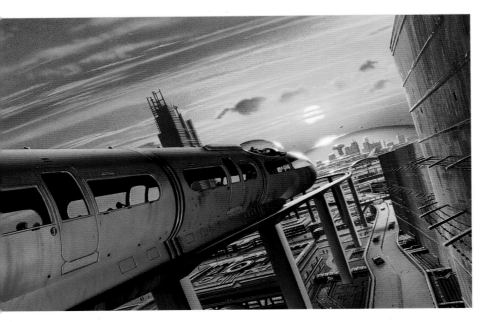

The Time Machine and The War of the Worlds

Published under the same cover, I thought it would be nice to have Big Ben standing as a timepiece along with the Martian tripod in the foreground, giving a presence to both themes in the same image. I very much wanted the atmosphere to be British and Wellsian. When people think of *The War of the Worlds* the image in their minds will often be from the Gene Barry movie.

Above:
No Earthly Connection:
Rick Wakeman
Inks on O. & R. line board
16x16ins (41x41cms)
A&M Records, album 1979

Top:
Only Forward
Acrylics on Crescent board
15x9ins (38x23cms)
Bantam Books, cover 2000

Right:
Unaccompanied
Sonata
Orson Scott Card
Inks & Acrylics on line board
10x15ins (26x38cms)
Grafton Books, cover 1982

Had you put the bags there in the first place?

Yes, well, she had bags under her eyes!

How chivalrous!

Well, they weren't huge, they were just little lines . . .

Were album covers a big thing for you at that time?

I did quite a few. I did the one for Rick Wakeman and then a Rod Stewart one and . . .

Which were they?

The Rick Wakeman was called *No Earthly Connection*, which involved designing a plane anamorph image. It's a very old process and I'm not exactly sure when it dates from. You know that Holbein painting (*The Ambassadors*) where there's a skull that you can only see properly from a certain angle? Well, it's a development of that. It had a practical use, as a form of identification. A person would carry a picture that was distorted, and if you held a polished pewter mug in the centre of it, the reflection in the pewter mug actually re-distorted the image so that it looked like the person. What Rick wanted was a

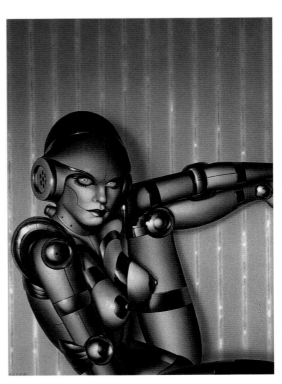

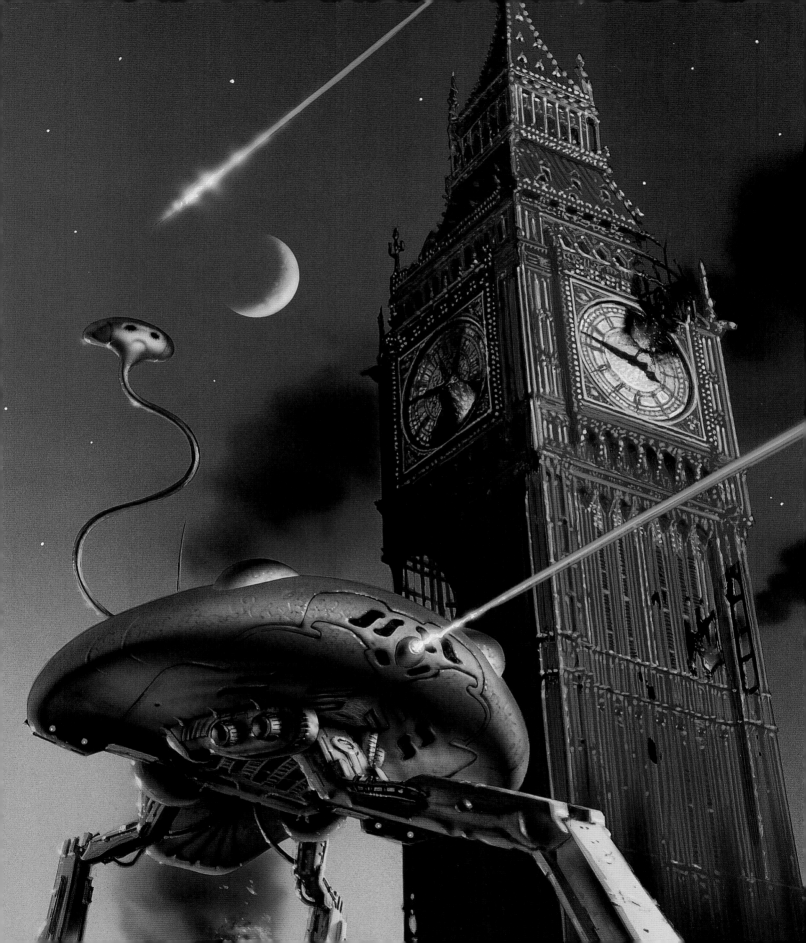

Previous page:
The Time Machine/
War of the Worlds
H.G. Wells
Acrylics on Crescent board
18x11.5ins (46x29cms)
Orion Books
Book cover 1998

Right:
Baseball chrome
Acrylics on Crescent board
5x5ins (12x12cms)
Illustration for Oxychem
Corporation Advertisement
Features buttons to select the
type of throw required 1994

Top right:
Baseball
Acrylics on Crescent board
5x5ins (12x12cms)
Salem cigarettes 1995

Opposite, top:
Fish
Acrylic on Crescent board
10x15ins (25x38cms)
Magazine cover for **Analog**
Magazine *1995*

**Opposite, below
left:**
Zombie
Michael Slade
Acrylics on Crescent board
10x19ins (26x48cms)
Hodder Headline
Book cover 1993

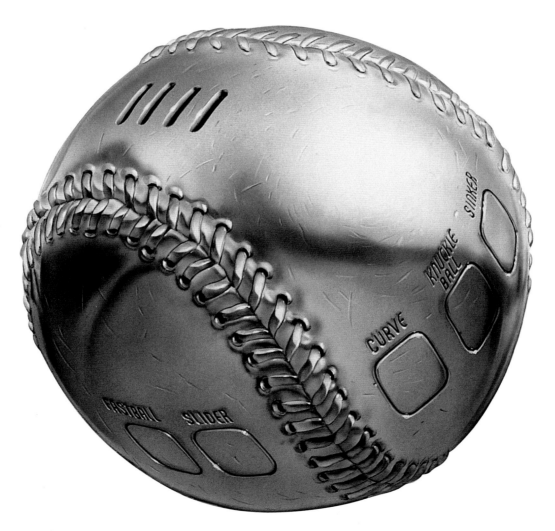

picture of him floating in the clouds, playing his keyboard, but distorted. When you bought the record, you got this sheet of mirror paper which you'd roll up and stand in the middle of the picture in order to see the image. There were all sorts of things that happened with it – there were posters on Hollywood Boulevard saying, 'See this sleeve come alive.' It really was big-time. I think I got paid £1,500 for doing the cover, which was a pittance. They even had a competition in *Amateur Photographer* magazine.

To do what?

They offered three rolls of film to anybody who could write in with an explanation as to how this photograph was taken. It wasn't a photograph, because I'd painted it. It's actually got to be worked up to quite a careful mathematical formula: there isn't a way of photographing it. Or there wasn't at the time. There probably is now. So I did that one, and we did quite a lot for Phonogram and for Polydor.

Rod Stewart, you said you did.

We did a compilation for him. We did various Status Quo albums, one for a band with Transatlantic Records called Pentangle.

I remember them. Folky bunch with Bert Jansch on guitar and a female vocalist.

I'd been sitting there trying to think of an idea, because the deadline was looming. I came up with a few things, but I wasn't happy with any of them. I got a cab over there with my pile of roughs, and as the cab drew up outside the office it suddenly hit me what I had to do. So I said to the cab driver, 'Just drive round the block, will you?' And I got my pen out and did this new rough in the back of the car. Then I ran in, and I didn't show them any of the others. I said, 'We should do this,' and they said, 'Great.' And what it was, was a pentangle-shaped record. You know how you'd get a vinyl LP inside a plastic sleeve? Well, I did a trompe l'oeil plastic sleeve with what looked like a real record inside it, but it was five-sided, pentangle-shaped.

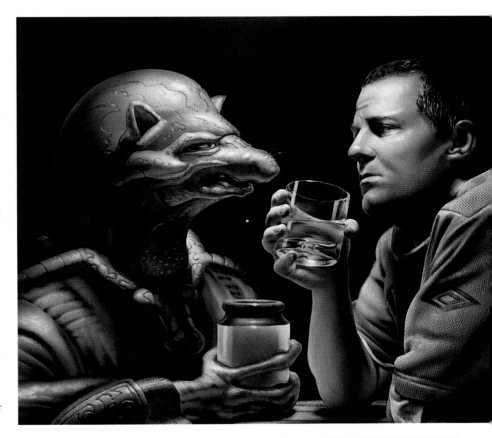

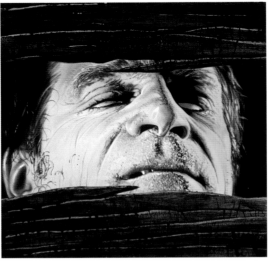

Above:
Pentangling:
Pentangle
*Inks on Oram & Robinson
line board
16x16ins (41x41cms)
Transatlantic Records
Album cover 1979*

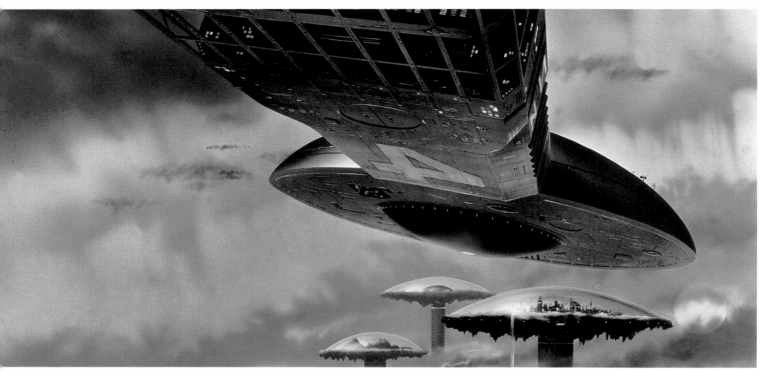

Above:
A Choice of Gods
Clifford D. Simak
Inks and Gouache on
line board
20x15ins (51x38cms)
Methuen
Book cover 1979

'

A Choice of Gods

This was one of the first wraparound covers I ever did. It was mainly conceived as a device for selling books to the book-shops, because it gave the publishers' reps a larger picture to wave under the noses of the book buyers. I developed this idea of having something sweeping across from the back cover and onto the front of the book. Prior to that, the back cover had always tended to be a dead area of the design.

'

But the disc itself was never pentangle-shaped.

No, it was just a regular disc.

You don't do the political thing, then, of showing five ideas, four of which you know they won't like? Which is always tricky because there's always the danger that they'll like one that you hate. Or do you have to play that game sometimes?

Well, it's all changed. You do have to, now. Although over the years I suppose you develop some kind of feel for what's going to work and what isn't, and I'd much rather go with that than present a load of stuff that I know is just going to give me problems at the end of the day.

Have you ever had to walk away from a job that you knew wasn't going to work out, because what they wanted from you was something you weren't either prepared or able to give? Or have you always been able to accommodate?

I've always been able to accommodate, but I have tried to walk away from jobs. There was one – a record cover for a band called Magnum, and . . . haven't I told you this story?

I don't think so.

Magnum was a band based in Birmingham. I think they were mates of Electric Light Orchestra, out of that stable. They called me in to talk about their new record and I sat there listening to it in Polydor's new reception suite in this mews in Mayfair. It was a dead swanky posh boardroom, with this black iron kitchen range down one side. The art director was German and he told me that this used to be Clive of Arabia's kitchen. I asked him if he meant Lawrence of India, but he didn't get it. Anyway, they played me this record, and after they'd played me a track and a half I said, 'OK, I've heard enough. I've got the idea.' I thought it was awful. The main man of the band was a bloke called Tony Clarkin. He was about five-foot nothing, bald, with a big beard, open shirt, medallion, and this big hat like a sombrero. And he said he'd had this dream, and it was like this evil entity in the form of a psychedelic eagle coming through a window into a big pink marble room, and there was this unicorn shying away from it in terror. The unicorn was supposed to symbolize peace. I said, 'Yes . . .' And he said, 'That's the idea. That's it.'

Sounds like a moment from *This is Spinal Tap*.

I think he'd seen *Legend*, the Ridley Scott film, the week before. I sat and thought about it for a minute and said, 'Well, OK, I don't mind this pink marble room. We could do something with that. But how about if you're looking out of this window, and across the water there's a mountain range and a blue sky. You've got a spiral galaxy in the sky, and then in the lake at the foot of these mountains there's a whirlpool. Then, as you come into the room, there's a whirlpool-shaped mosaic in the floor. And then in the corner, there's one of these old-style record players with a record on it, so it's like four stages of style from this little record to the spiral galaxy.'

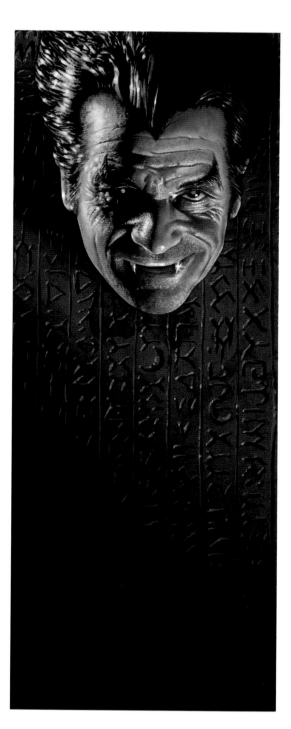

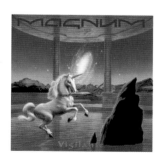

‘ **Zombie/The Book of Common Dread**
The model for both of these is a friend named Dave, who also happens to be one of the consultants at the local hospital. He's got a print on the wall of his operating theatre. The patients see it as they're being wheeled in, and it's probably the last thing they remember as they go under. ’

Above:
Vigilante/Magnum
Acrylic on Schoeleshammer board
15.5x15.5ins (39x39cm)
Polydor Records
Album cover 1989

Left:
The Book of Common Dread
Brent Monahan
Acrylic on Crescent board
9x14ins (23x35cms)
Hodder Headline
Paperback cover 1993

What did he say to that?

He said, 'What about the evil entity?'

So did you still end up doing this?

I did, yes. Eventually they just rang me up and said do what you like. But they still insisted on having this threatening entity. So I put a big rock in the middle – this rock that looked like it was just about to fall into the shape of a hooded monk or something. They never came back to me for their second album, I think they went back to using Rodney Matthews. They clearly preferred the gnomes and goblins treatment to the more conceptual approach. Nowadays I try to turn things down that are going to be problematic in that sense.

How do you know when something's going to be a problem?

You just get a feeling for it.

Are there certain people you tend to deal with over and over? If there's someone who you haven't dealt with before, do you tend to approach them with a little more caution?

Well, I don't often work for people directly any more. I usually go through whichever agent I'm using. Although for a long time I didn't have an agent at all. So I was quite used to dealing with clients.

Were you a businesslike person back then?

Not really, no.

So did you find, when you moved from dealing for yourself to dealing through an agent, that things improved business-wise?

No. It's always been the same. I've always lived slightly beyond my means! I don't end up being hugely in debt, but I've always got an overdraft.

Right:
The Days of
Perky Pat
Philip K. Dick
Acrylic on Crescent board
20x15ins (51x38cms)
Harper Collins
Wraparound cover for
Volume 4 of Philip K. Dicks
short stories 1993

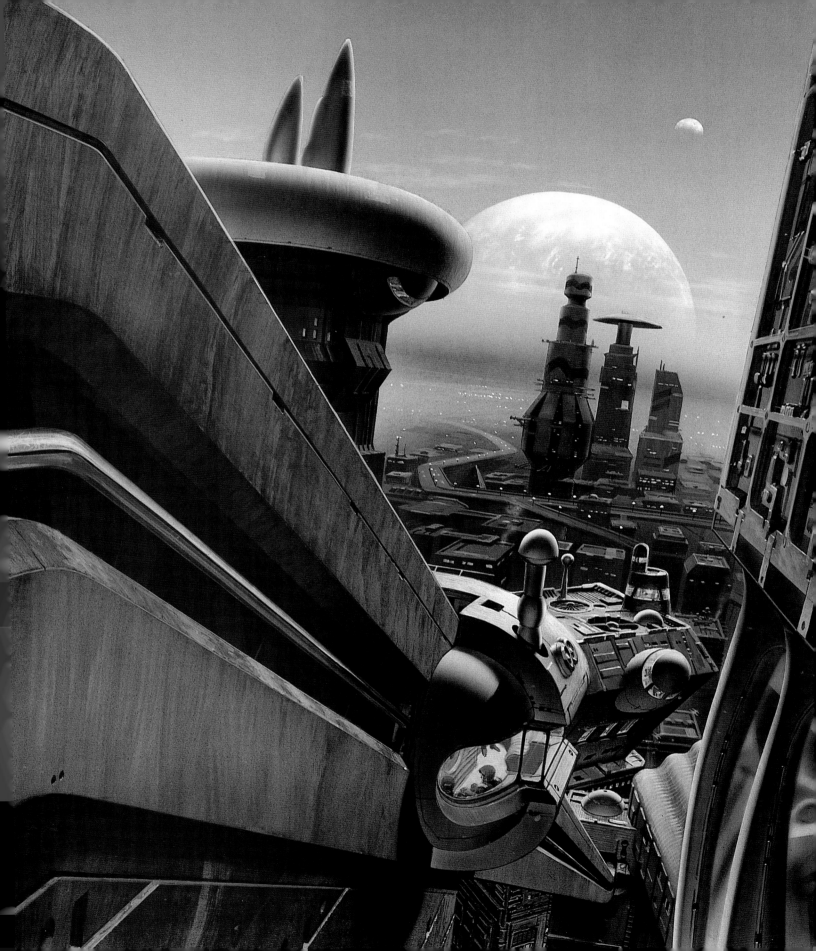

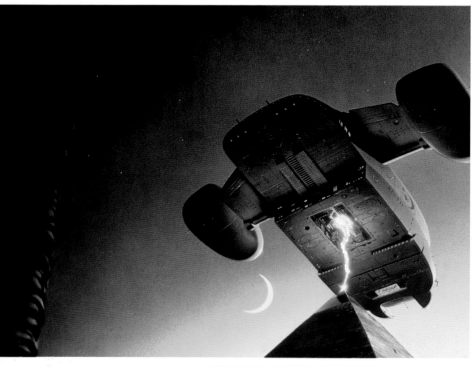

Above:
Hot Sleep
Orson Scott Card
Inks on CS10 line board
22x15ins (56x38cms)
Hamlyn Books
Wraparound cover 1981

Right:
The Complete Robot
Isaac Asimov
Acrylic on Crescent board
10x15.5ins (26x39cms)
Harper Collins
Book cover 1996

Far Right:
Sons of Heaven
Terence Strong
The Fifth Hostage
Terence Strong
Acrylic on Crescent board
20x15ins (51x38cms)
Hodder Headline
Mass-market paperback
cover 1998

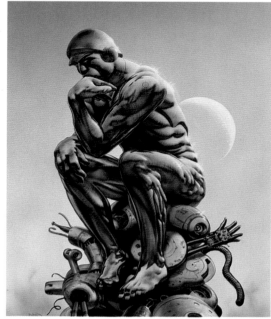

So how do you organize your finances professionally?

Well, I usually have to wait two to three months for any payment anyway, so I kind of work on the principle that, as I'm doing the work, I'm earning Brownie points which will eventually materialize as money. But, other than that, I don't really worry about it.

You don't feel a direct connection between work and money, then?

Well, no, because you don't actually see the money. A cheque comes in every so often.

And by then it's unrelated to what you did to earn it.

Yes, and if people had any kind of foresight at all within this business they would realize that, if somebody knew they were going to get paid quickly, or even instantly, then they'd be much more willing to actually put themselves out and produce a damn' good job.

Do you not find that, once you get into the work, then the work takes over, regardless of whoever might have asked you to do it, or what the rewards might be at the end?

No. It's always a struggle.

Being a commercial artist means that your work is always a reaction to someone else's need. I'm wondering how that affects the satisfaction you're able to get out of it.

Well, it kind of goes back to when I was a kid and you do things for praise, really. And that's always been another bone of contention for me — that, largely, in this country you don't get praised for what you do. People are at best indifferent, and it's wrong. In America you don't get that. You don't only get praise, you get pre-praise. You get people ringing you up saying, 'Thanks very much for agreeing to do this job. I'm so excited about working with you.' I've never heard anything like that over here.

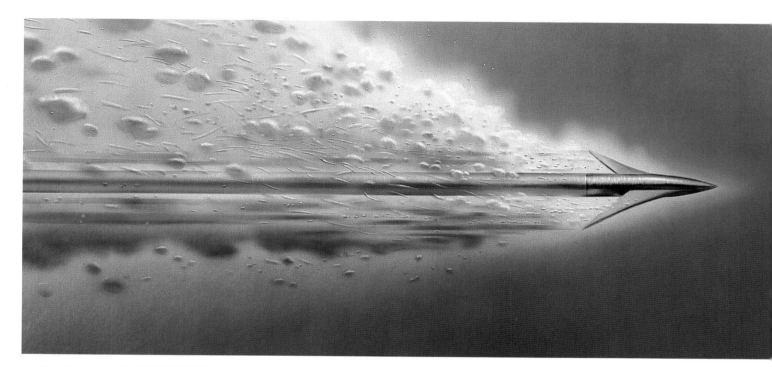

The Stars My Destination (Tiger! Tiger!)

The model for this one was a local building contractor wearing my young daughter's bathing hat. All the way through the photo session I had to keep saying, 'Trust me! Trust me on this!' He was apprehensive about the effect but he was delighted with the result.

You've never been tempted to go to America, then, and live that life all the time, as opposed to at a distance?

I don't know, really. Katie and I are talking about possibly moving abroad eventually, but I don't think I'd want to go and live in America. Certain parts of America, maybe . . .

When you say that, are you thinking of living and working abroad, or packing it in and being a beach bum somewhere?

Oh, no, I'll always do something. I don't like sitting around doing nothing. That's why I'm into music, because it's an antidote to the stress of being an illustrator. It is actually hard work having to come up with the goods all the time, sitting there trying to churn these things out, trying to be good all the time. It's hard work.

Right:
The Stars My Destination
Alfred Bester
Acrylics on Crescent board
18x11.5ins (46x29cms)
Orion Books
Book cover 1998

Left:
Glaice
L. Warren Douglas
Acrylic on Crescent board
8x14ins (21x36cms)
ROC/Penguin Books USA
Paperback cover 1996

Islands in The Net

The original artwork for this one disappeared or was stolen, so if anyone reading this has any idea where it is, I'd appreciate knowing...

ime to make a move.

The place hasn't exactly filled up, but there's enough noise coming out of a side room to be a distraction and, besides, I reckon we're due a break. We go out to my car, which stands in a walled parking area just a few dozen yards away from the pub. Although there's a full moon in a clear sky, back here the high walls cast shadows. It's so dark that I have to press the keyring remote so the car will light up as it unlocks, giving us something to aim for.

Live within a few miles of any big settlement and there's a level of ambient light in the sky at night, so ever-present that you don't notice it until it's missing. Country darkness can be unsettling. But it would be wrong to assume that, just because we seem to be isolated, we're in the middle of nowhere: half an hour's drive from this spot would get us to any one of eight or nine good-sized towns and the major roads, when you get onto them, are fast and direct.

What I'm saying is that it's isolation of a kind, but it's not cut-off, never-see-anyone isolation. We set off for the house and, for the moment, we stick to the lanes. By the stone bridge that crosses the river at the lower end of the village, our headlights pick up the forms of ducks that are sleeping on the embankment. Their shadows move like racing sundials as we pass them, but the sleeping birds don't stir.

THE ROUGH STUFF

The last time I visited Chris's studio, his parents – now in their eighties but still limber – called by with a bag of memorabilia gathered in the course of a recent house move. They now live in a bungalow less than half an hour's drive away. The bag included some pieces from his teenaged years and his report book from school.

Thinking of that as we're moving along, I connect it with what he's told me about his early certainties regarding the profession he'd one day enter. The entries from Miss Martin, his art teacher, had been at the bottom of every page in the report book, so it was possible to flick through and quickly get a sense of his progress. Or, at least, his progress as seen through his art teacher's eyes.

It was immediately obvious that she'd been aware of his promise, and had seen a bright future for him. His best work was praised for its exceptional display of talent. When what he turned in represented less than his best, she made sure he knew about it. From those few lines, she comes over as both his biggest fan and his sternest critic.

Not too long ago, Fred Moore, Chris's father, tracked down her address and went to see her.

Right:
Islands in The Net
Acrylic on Crescent board
22x15ins (56x38cms)
Wraparound cover 1987

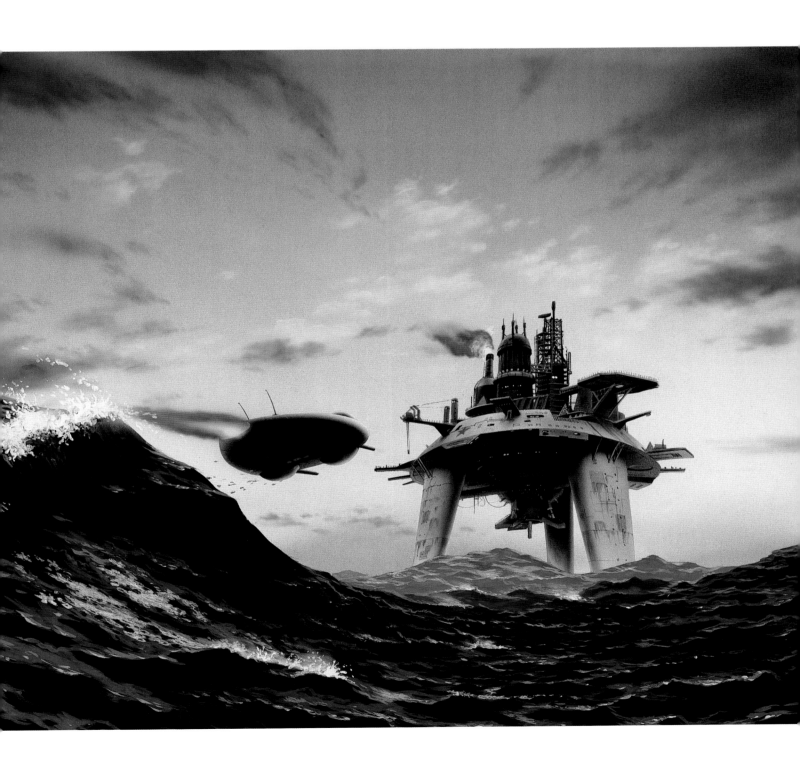

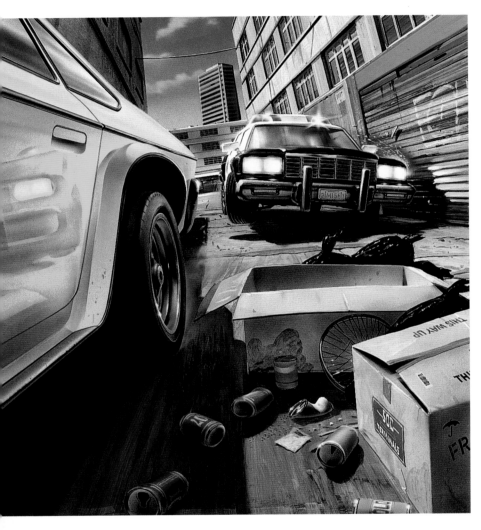

Above:
Driver
Acrylic on Crescent board
12x20ins (30x51cms)
Sony
Computer game cover 1998

Far Right:
Force of Eagles
Richard Herman
Acrylic on Crescent board
9.5x14ins (24x36cms)
Hodder Headline
Book cover 1996

Chris told me: 'I'd made various noises about getting in touch with her, just to thank her, really, for what she did. So my dad found out where she lived and he went round there and knocked on the door. And he didn't have to say a word. She just said, "It's Chris, isn't it?" This was quite amazing, nearly 40 years on. She sent me a plate that she'd designed.'

On through the night, up to a moonlit crossing. Five minutes later, we're there.

The studio outbuilding and the main part of the house are linked by a short, glazed passageway. We park under the lights of the courtyard and, after a stop to brew up some tea in the enormous farmhouse kitchen, we carry our mugs through into the working area. It's my idea now to get some idea of the artist's methodology, the nuts and bolts of how he does his job.

The big studio's up a flight of stairs, but we enter a smaller room below. About two years ago, Chris took the plunge into computer technology and installed some state-of-the-art kit. Everything's here, and humming.

There's some framed work on the walls, art and reference books lying in stacks everywhere, a couple of his guitars. As we talk, his two elderly spaniels wander in, inspect us, and wander off again.

‘ We're now in the – what do you call this room? Is it the office under the studio?

Computer room, really.

So what's your setup here? You've got this enormous Mac with two big monitors, and I think I've also seen another Mac upstairs.

This is the one I use for actual artwork. At first I was using it to build up a database of everything that I've ever done, but then I switched all of that onto the machine upstairs. That one will eventually carry the complete database. There are about eight hundred images scanned into it so far. I let the kids play computer games on it as well.

Is it just a record of the images? Or what is it?

Basically it's an image for each cover plus a list of all the various rights that are sold on it.

(Chris calls up the incomplete database just to give me some idea of how it's laid out, and what it records. Often a painting has a life that extends way beyond its original appearance. Unless the original commissioning deal is for an all-rights buy-out, an image can be resold into other markets. In the case of book-cover art, this usually means to foreign publishers. Sometimes they'll use the same art for their own editions of the novel. Or sometimes they'll use the image for some other book altogether. The database records the commercial life of each image with dates, publisher names, prices paid. As we talk, we page through the various files.)

Some of them are full covers, and some of them are just the naked artwork.

Yes, it depends on what was available in terms of a resource to scan in.

These scanned images — are these just for this archive, or could you output them?

No, they're far too low-resolution. It's just a record.

And is the intention that you'll get absolutely everything onto there?

Yes. I'll update it every six months or so. Spend a couple of days scanning a load of stuff in.

When I first knew you, you didn't work with a computer at all. Then a couple of years ago you dived in and bought all this gear, and there was a period where you were going through the agonies of getting to know your way around it. Now it seems your working method has very much incorporated the computer, even if you haven't gone a hundred per cent digital. You do all your roughs on this now, is that right?

I do a lot of them, yes.

What are you using there? Adobe Photoshop?

Yes. Do you want me to carry on flicking through this?

Above:
Alpha Centauri
Michael Capobianco
Acrylics on Crescent board
23x17ins (58x43cms)
Avon Books
Wraparound book cover 1993

Right:
Ares
Stephen Baxter
Acrylics on Crescent board
11x19ins (28x48cms)
Harper Collins
Hardback and paperback
cover 1992

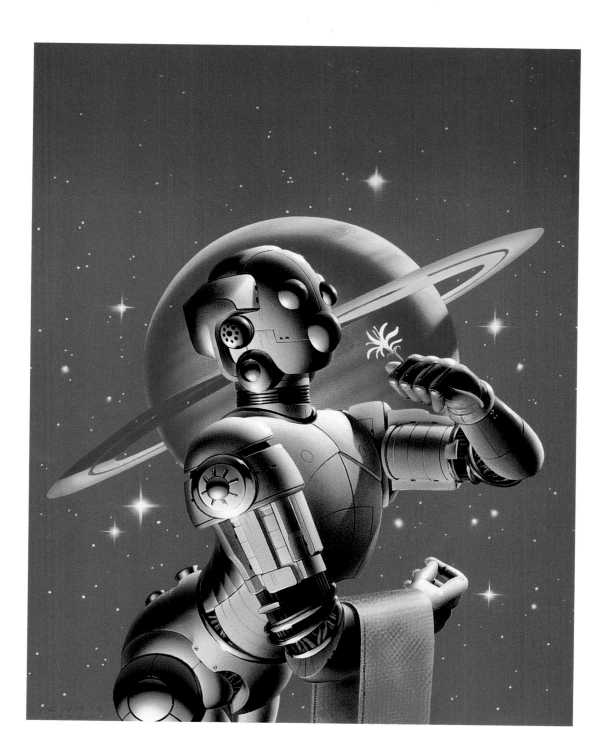

Special Deliverance
This was part of a series of Simak novels, and the art director wanted the artwork to be composed around a circular motif on each of the covers. There were a number of them, and some of them became quite ingenious. The crescent moon, or some form of it, is a recurrent image in a large number of my science-fiction paintings. It turns up so often that I've started to think that it's become an unintentional signature.
'

Left:
Special Deliverance
Clifford D. Simak
Inks and Acrylics on line board
10x15ins (25x38cms)
Methuen
Paperback cover 1977

Overleaf:
The Legacy of Heorot
Larry Niven, Jerry Pournelle
& Steven Barnes
20x15ins (51x38cms)
Acrylic on Crescent board
Sphere Books
Wraparound paperback cover 1992

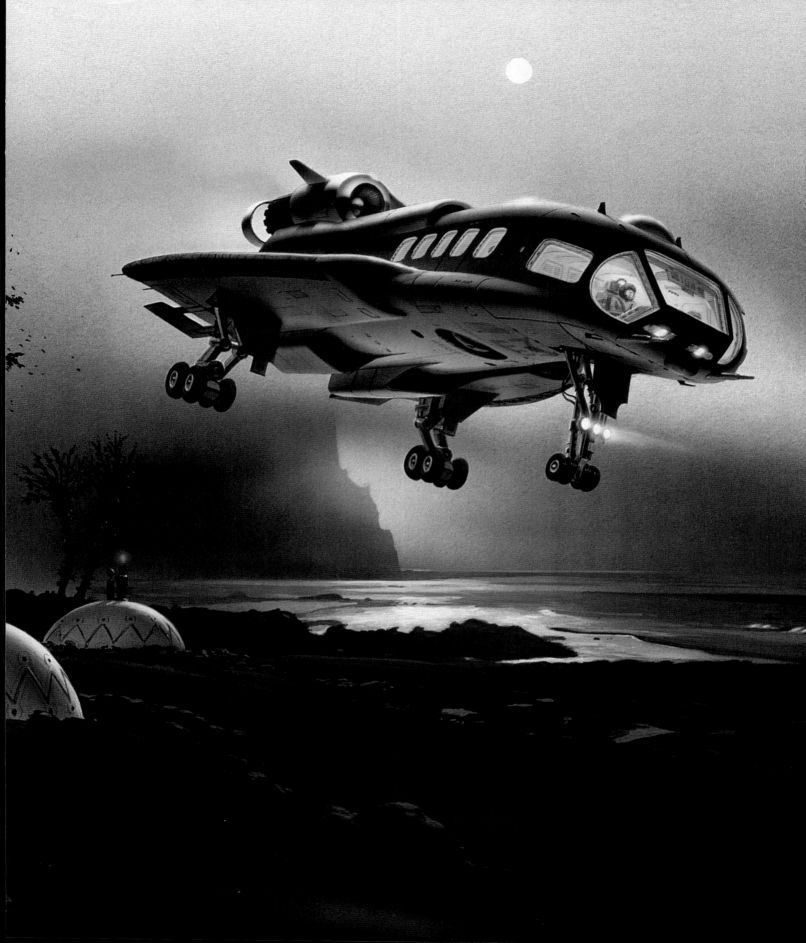

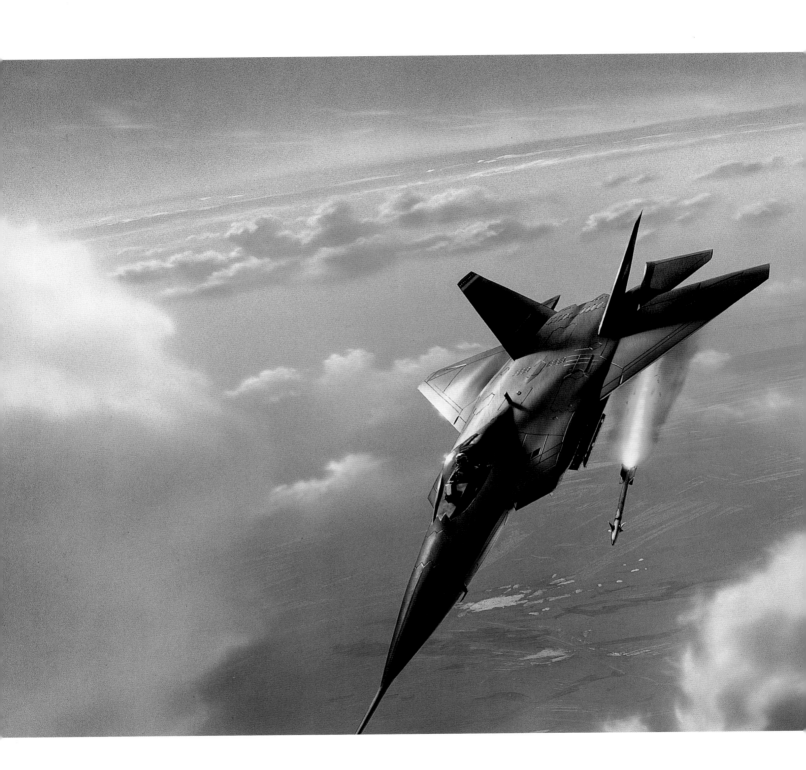

Yes, why not? You've done quite a range of stuff, haven't you? You're widely known as a science-fiction artist, but I suppose that's because people who read science fiction are more aware of their artists than other people tend to be. But I'm seeing a lot of blockbusters and bestsellers here . . . Thomas Harris, Jeffrey Archer, Stephen Coonts, Jackie Collins . . .

Yes, that's right, I get a lot of those . . .

It's not exclusively high-tech and hardware, but there's a lot of that. A lot of contemporary thrillers.

I once had an e-mail from the President of the Colin Forbes Appreciation Society, asking if I'd answer some questions. In one of them he wanted to know why there seemed to be a difference between the earlier covers that I'd done, which were reprints, and the newer ones. He reckoned the later ones seemed to be more involved and more complicated. And my response was to say that they were not really that successful, I didn't think, because whoever commissioned them didn't know his arse from his elbow. They wanted everything but the kitchen sink in there, which never makes for a good cover.
 See, here's one. You can't really see it on this, but all this bridge here is sort of collapsing into the sea at the bottom, and there's a limousine skidding to a halt on the bridge as it's collapsing, and the car's tail-lights are burning, and there's a mist coming across the moon here, with a hillside down here. Get the picture? So I said to the Colin Forbes fan, 'Whoever it was, I wish they'd kept their mouth shut.' And it turned out later that all that input had actually come from Colin Forbes himself. I haven't heard anything from him since.

Out of all this variety, what kind of work are you happiest doing?

If I didn't have to earn a living, I would do the science-fiction work all the time. That would be if I didn't have to worry about keeping up my side of the bargain I have with Katie. We have a sort of pact – although, to be honest, she always says it doesn't matter, I should do what I like, because luckily we don't have to struggle about money just at this moment. But, if I felt I had a choice, I would do bigger paintings, more elaborate paintings, more involved paintings.

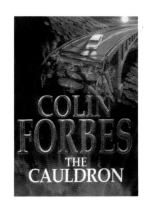

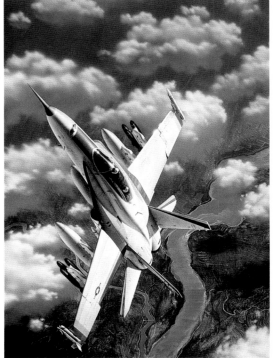

Above:
The Cauldron
Colin Forbes
Acrylics on Crescent board
12x18ins (31x46cms)
Pan Books
Book cover 1992

Top left:
Light Thickens
Ngaio Marsh
Self-portrait
Ink on lineboard
11x16.5ins (28x42cms)
Fontana Books
Book cover 1976

Left:
The Day of The Cheetah
Dale Brown
Acrylic on Crescent board
9.5x14ins (24x36cms)
Hodder Headline
Book cover 1993

Far left:
Fortunes of War
Stephen Coonts
Acrylic on Crescent board
23x17ins (59x43cms)
Millennium
Book cover 1999

Nimisha's Ship

This was the very first cover I produced with the help of a computer. I worked out all the roughs and brought the elements together on screen, and then I worked from that to the finished painting. There's nothing of the computer in the final image – that's a conventional picture. I just used the computer for the working-out and construction, not for the execution.

So you'd be a science-fiction landscape artist?

Well, I've always been a landscape painter. A frustrated one, really, in that I don't often get a chance to do landscapes.

(We exit the database and call up the current files on some works in progress.)

What's the very first step in producing a cover painting?

Well, they'll send me the book . . .

And you, of course, always read every book you work on . . .

Of course! If it's a reprint you might get a file copy. If it's something new you'll get proofs or a manuscript to read.

Are you quite at ease reading a book in manuscript form? Not everyone is. Even I find it tricky if it's someone else's work.

I quick-read them. I'm used to the look of them by now.

What are you looking for when you read? Are you looking for a big image to leap out at you, or are you looking for incident?

Well, the publishers have probably given you some idea of what they're wanting, so you're looking at it with that in mind. I think I produce a lot more paintings than some other illustrators, and because of that I don't have the time to read as much as I'd like. Quite often, I'll read a book so far until I've got something, and then I'll abandon it. That's just the way it is.

We're looking at some very early roughs for a cover on the big screen now. How were these done?

They're just done on here. I use a graphics tablet and a light pen.

And what it gives you is the look of a pencil drawing on the screen, doesn't it?

It does, yes.

Right:
Nimisha's Ship
Anne McCaffrey
Acrylic on Crescent board
22x15.5ins (56x39cms)
Transworld
Wraparound paperback cover
1999

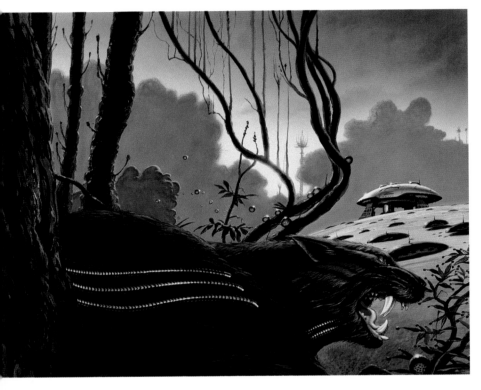

Above:
The Winds of Altair
Ben Bova
Inks and Acrylics on Oram
and Robinson line board
10x16ins (25x41cms)
Methuen Books
Wraparound book cover 1984

Right:
Man Plus
Frederick Pohl
Acrylic on Crescent board
10x16ins (25x41cms)
Orion Books Masterworks ·
series
Book cover 1999

So do you find that you prefer to work with a graphics tablet rather than a piece of paper now?

No, but by using this you've got the added facility of e-mail. You can send the actual pictures back and forth down the line for discussion.

What we're looking at here is a very scribbly rough, isn't it? It's almost what you'd call a back-of-an-envelope drawing.

It's just to get the general idea and the composition.

We're now calling up different files of more finished artwork on the same title. So we're not looking at . . . Is that the finished artwork there?

No, that's a later version of the rough.

Because I find it quite difficult to distinguish some of your roughs from the finished artwork — your roughs are so finished!

The figure in the foreground is a photograph that's been stripped in. It's one of the doctors down at Katie's hospital, striking a sufficiently — what's that word I'm looking for — heroic pose?

So what do you do? Do you recruit models from amongst your friends and photograph them?

That's right. I use the photograph itself for the rough and then I'll use it for reference when I'm doing the painting. I'll get you in there before long. Apart from the photograph, the rest of this is just drawn.

Is that drawn on the graphics tablet, or is that scanned-in artwork?

No, it's the same drawing that I started with. I've just made it more detailed.

So you've taken the dog-rough, back-of-the-envelope pencil drawing, enhanced it and added colour, and worked over it and added a figure from a photograph. And changed all the tonal values?

Balanced them up, yes.

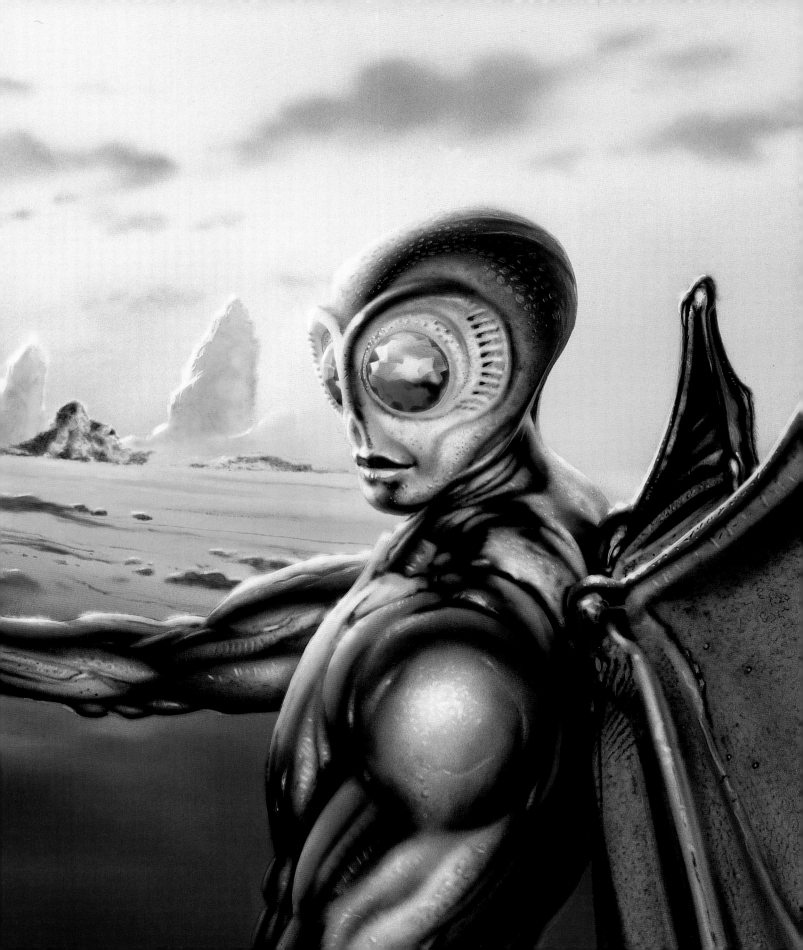

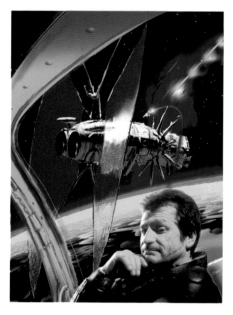

So that's now looking . . . A lot of people would put that forward as their finished art, and this is your rough.

Really? Well, in fact, Vonda McIntyre thought it was the artwork, I must admit.

This is a whole different way of doing the job, isn't it? There are people who do collage art with computers – and I'm thinking now of people like Dave McKean – where you're clearly meant to be conscious of the artifice in the way he's taken elements and put them together. But what you've got here is more like a turbo-assisted version of a traditional method.

Well, I draw. I like drawing. I've dabbled with a landscaping program called Bryce but it didn't do much for me, because it's so recognizable. That's half the problem with computers, that the programs that you're using can have an influence over the way the thing looks.

Is there a point at which you stop feeling that you're in control and that you're merely assembling?

No, I think you're in control all the time.

(We move on to another image, one that eventually became the cover for an Anne McCaffrey novel, and Chris puts the rough onscreen alongside the finished artwork for comparison.)

To me, the difference here is between two different approaches rather than two different levels of finish. The difference is conceptual rather than qualitative.

What do you mean by that?

I suppose what I mean is that, when I look at the rough, what I see is a finished piece of artwork done in more of a free style.

Yes. In fact, there have been occasions when I've actually tried to encourage people to use roughs as finished artwork, because I quite like the sort of loose quality of them. But they're very reluctant to do that, for some reason, which makes me think that perhaps the quality's not what I think it is.

Or perhaps it's because they're aware that they're looking at roughs, and that prejudices them.

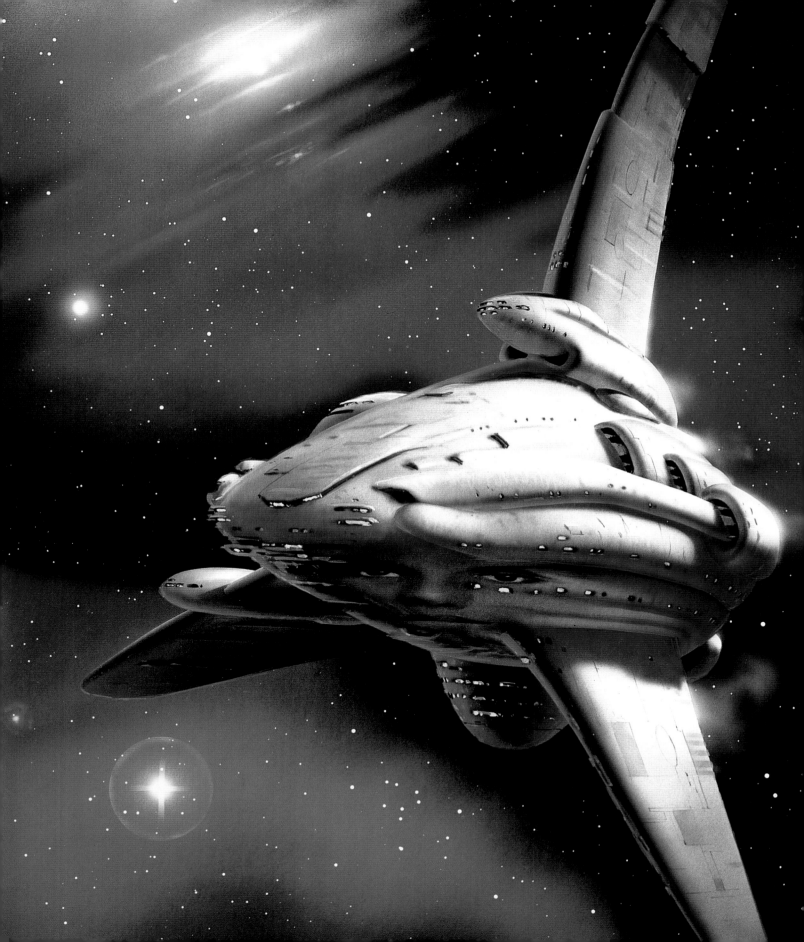

Flow My Tears the Policeman Said

'I wanted to introduce a kind of narrative tension into this picture. You can see it in the way that the woman in the car is visibly irritated and waiting for the man to come over, while his attention is on another figure in the background. But when the notes came back I had to put sunglasses on the foreground figure in the finished picture, which for me diminished that particular effect.'

Right:
Flow My Tears the Policeman Said
Philip K. Dick
Acrylic on Crescent board
22x15ins (56x38cms)
Harper Collins
Wraparound cover 1996

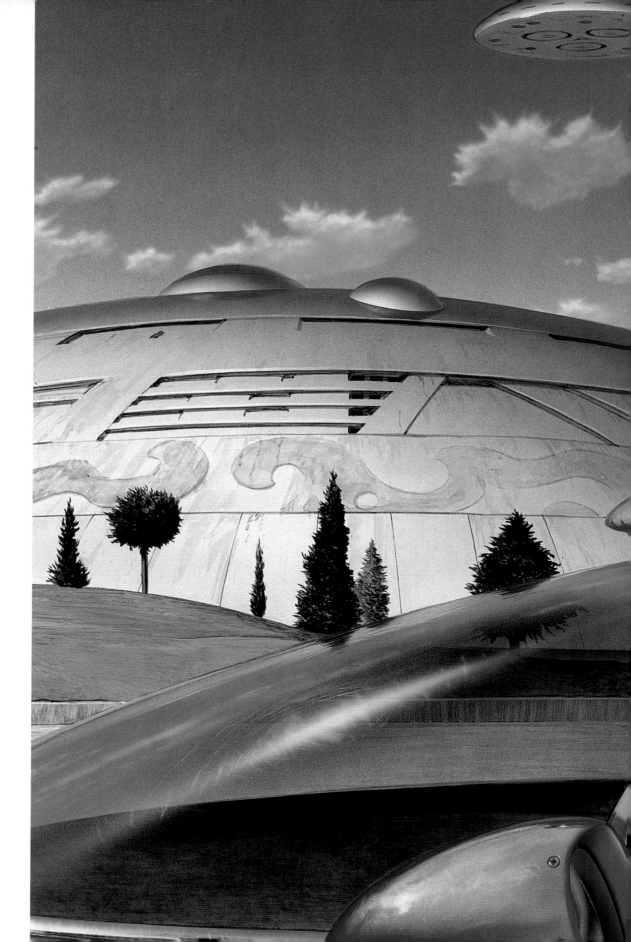

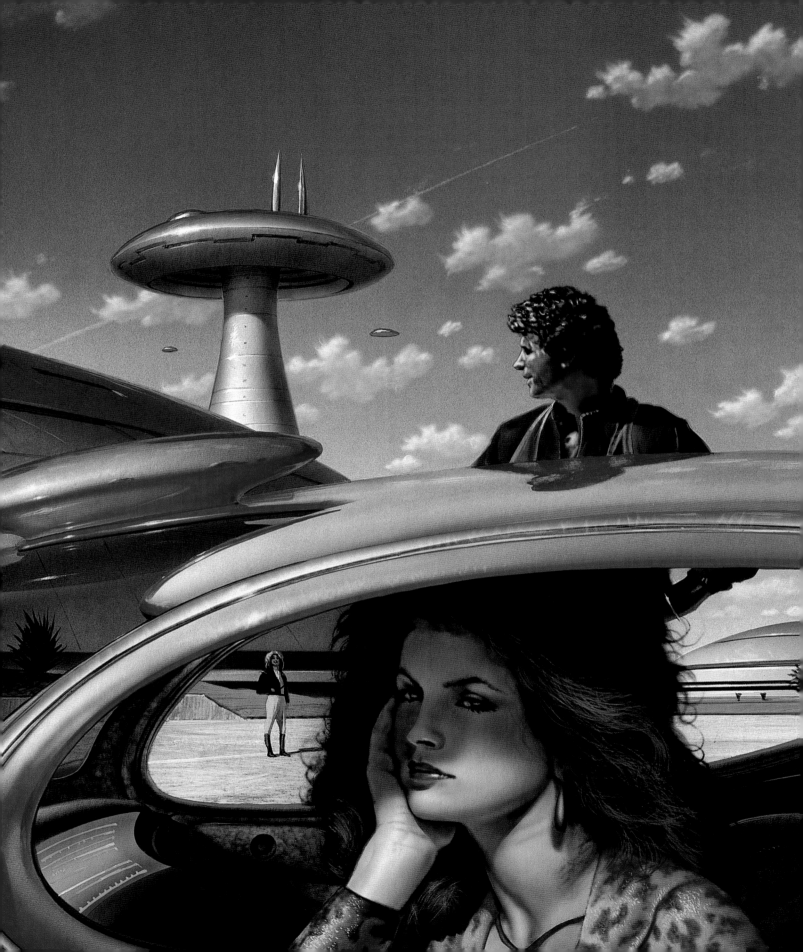

Flowers for Algernon

I went out and bought a pet mouse to use as a model for this cover. Then I felt it was cruel to keep one mouse in a cage on its own, so I bought another to keep it company. I told my youngest son that he could consider them as his, but then it escalated because my daughter wanted a pet of her own, and the next thing was we had a couple of rabbits. Of course, they don't look after them. I do. So now I'm stuck with this expanding zoo.

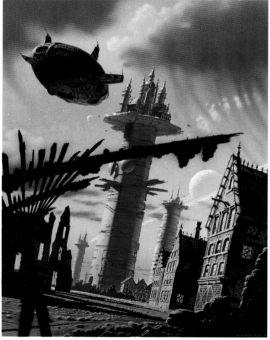

Above:
Flowers for Algernon
Daniel Keyes
Acrylic on Crescent board
10x16ins (25x41cms)
Orion Books Masterworks series
Book cover 1998

Right:
Emphyrio
Jack Vance
Acrylic on Crescent board
10x16ins (25x41cms)
Orion Books Masterworks series
Book cover 1998

I can show you quite a few examples of this, where the rough has worked quite well, and then I've virtually gone through the same process again, but in paint, to produce something which is marginally better, or pretty much the same.

Do you sometimes find that the rough has an advantage of spontaneity which you just can't reproduce?

Yes.

I remember some of the covers to my books. I've had covers where I've loved the roughs, and been very cool towards the finished artwork.

The thing is, you see, I can do the rough in two hours. It may take me five days to do the finished artwork.

Maybe you should do the thing in two hours, and wait five days before you send it in?

Maybe I should! There is a difference, though. There's a lot of work in the finished art. I'm sure that anyone who's genuinely interested is going to appreciate the level of detail and all that kind of stuff.

But wasn't there a story about – Man Ray, was it? – being shown a reel of the pencil tests for one of Disney's films, and saying, 'That's the one you should show.' Because all the energy was there in the pencils, but by the time it had been cleaned up some of the life had gone out of it.

Well, I can sometimes feel a bit like that.

(In the next example, we compare two new images – this time we look at both the finished painting and the cover it became. There's a substantial difference between the two. Part of the painting has been selected out, enlarged and cropped. At least a third if not half of the painting has gone. The resulting image is crowded and busy, and has lost much of its impact.)

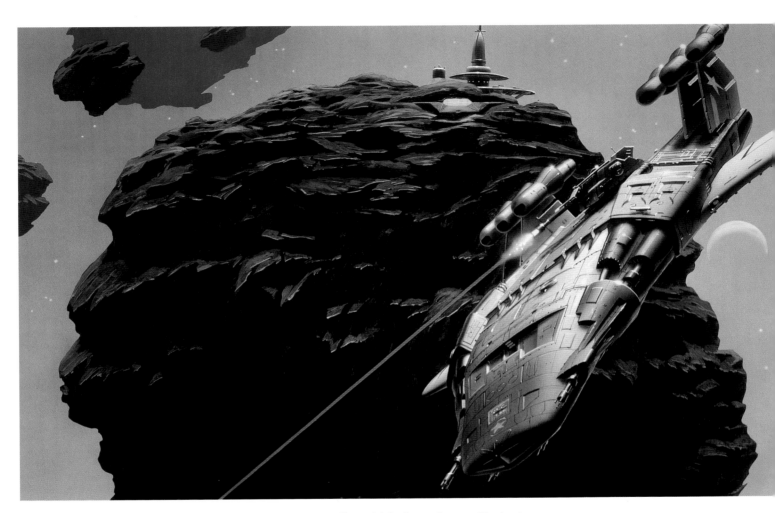

It must be heartbreaking from your point of view to get a composition right and then to have it treated as raw material for re-composition.

All my interest is in actually doing the thing, rather than in what happens to it afterwards. I mean, I've a passing interest in it when it's out there and on a book, but I've done so many of them now that it doesn't really worry me too much.

You don't want to follow every job through to its final conclusion?

Not really. I think that as long as I'm in there, batting with the rest of them, then I'm happy. I've never been that precious about what I do. It doesn't pay to be precious. It gets in between what you're doing and what the art director wants.

Having said that, are there some art directors out there – without naming names – who make your heart sink when you know you'll be doing work for them, because you dread to think how it's going to end up?

No, there's no one I feel like that about. But I don't think there are very many people around now who are what I'd call real art directors.

Above:
All Flesh is Grass
Clifford D. Simak
Inks and Poster Colour on
CS10 line board
22x16ins (56x41cms)
Methuen
Wraparound book cover 1982

Right:
The Collapsium
Wil McCarthy
Acrylic on Crescent board
13.5x21ins (34x53cms)
Orion Books
Hardback cover 1999

Below:
Bird of Paradise
Acrylic on Crescent board
15x15ins (38x38cms)
Oxychem Corporation
One of a series of adverts
showing the harmony between
nature and technology
(Is there any?) 1993

Far right:
Kinsman
Ben Bova
Acrylic on Crescent board
22x15ins (56x38cms)
Methuen
Wraparound paperback and
hardback cover 1987

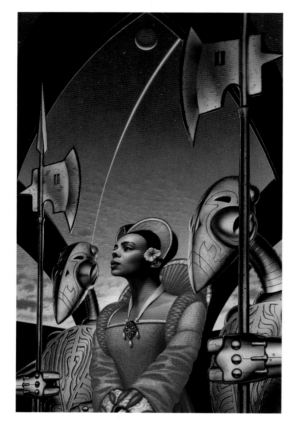

So how would you define a real art director, then?

Basically somebody who knows what they want, and trusts you to produce what they want, and gives you the responsibility of producing it. That's not always the case, these days. The problem with the computer is that it gives other people the power to interfere after the event. It undermines your responsibility as an artist because what you produce, in effect, doesn't really matter. As soon as you've given them the required ingredients for a cover, they can then start chopping it about and changing the colours and adding bits and cropping things out and moving them backwards and forwards.

Exercising their own artistic judgement?

That's right. But, from what I've experienced, I'm not sure that many of them have any.

Right:
Ringworld
Larry Niven
*Acrylic and inks on Crescent
board*
20x15ins (51x38cms)
Sphere Books
Wraparound paperback cover
1983

E ven though it's been barely a couple of weeks since the wintry night on which we began this conversation, the day is bright and warm. It's shirtsleeve weather, the first day of its kind this year. Not quite Spring, but not far from it if the young lambs in the fields are anything to go by. They're few in number, but they're out there.

There's an old horse trough in the yard. It's fed with fresh water by a stream at one end so that it constantly overflows at the other. I park alongside this and go inside to find Chris in the kitchen with nineteen-year-old son Will, who's moved up here to stay for a while. Will's on the phone. The atmosphere's easy and it turns out to be one of those days when it's hard to get things going in any productive way.

Before I became a freelance, I used to think that the best thing about the life would be the ability to take time off whenever I wanted. Once I was into it, I realized that it's also one of the worst things about the life. Nobody

THE SERIOUS BUSINESS

pushes you to work; no one will pick you up if you fall. If Fred Moore once feared that his son might lack self-discipline, he needn't have worried. A freelance without it is soon in trouble. The only momentum you ever have is the momentum you can generate.

And you have to generate it every single day.

We finally get to it, and leave Will in long-distance conversation with his brother Rob as we make our way to the big studio upstairs. This occupies the entire upper story of the outbuilding. At the far end of the space stand two full-sized drawing boards. They're positioned to get all the daylight from a window that takes up most of the gable end wall and looks out across open fields. The view isn't what you'd call chocolate-box pretty but it's real north-country terrain, the landscape of a Brontë novel. Looking out this way, there isn't a road or another dwelling in sight. I'm torn between thinking that on the one hand it's a desirable situation, while on the other these surroundings could be a serious distraction. As someone who's worked in a series of rented attics and now writes in a study where the blinds are permanently drawn, I'd have no chance in a room like this. But then, I've noticed that artists and writers seem to have different forms of concentration. I observe that Chris tends to work with the radio as background, usually tuned to BBC Radio Four.

Ringworld
One evening when my kids were watching *Top of the Pops* on television, one of them said, 'Hey, dad, there's one of your pictures on the telly.' And, there was this image, occupying the studio wall. I got my agent onto it and eventually found that the BBC had hired the backdrop from a company that had since gone into liquidation. Our lawyer pointed out that the BBC were still liable for the use of the image on-air. They finally agreed to offer their standard payment, which was barely two-thirds of what it had cost me in legal fees!

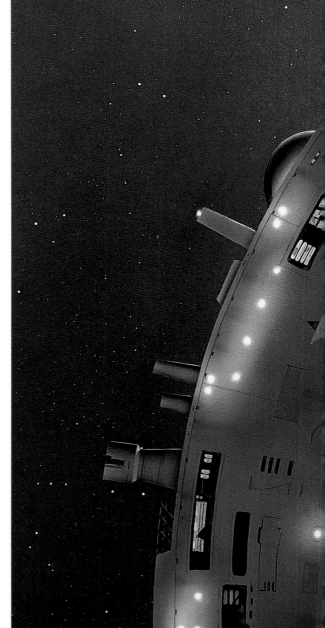

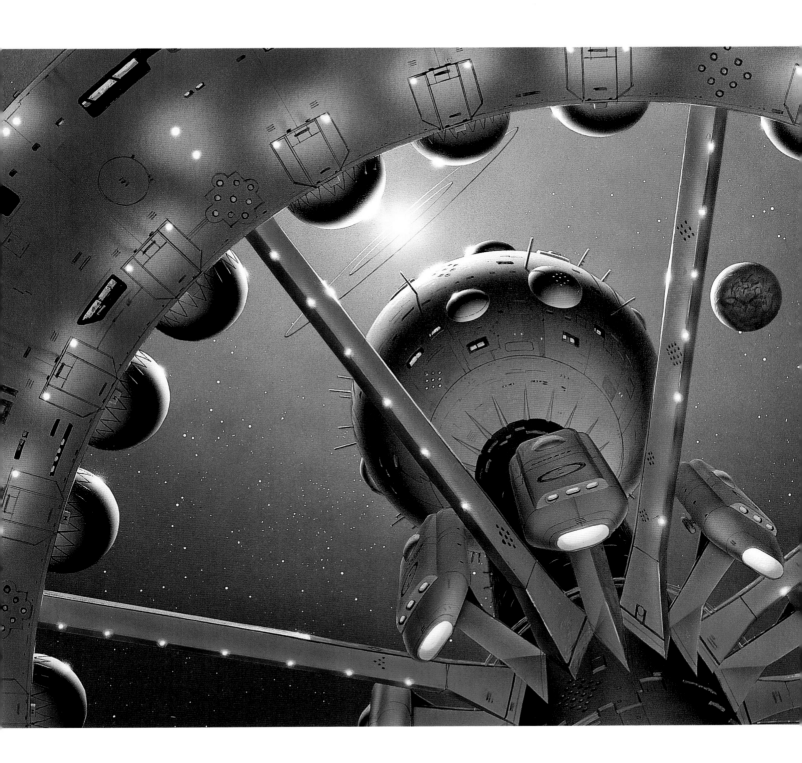

Right:
Renaissance
Raymond F. Jones
Acrylics on Crescent board
9x15ins (23x38cms)
Grafton Books
Paperback cover 1986

Below:
Noir
K.W. Jeter
Acrylics on Crescent board
23x18ins (58x46cms)
Orion Books
Wraparound book cover 1998

Far right:
We Can Remember It
For You Wholesale
Philip K. Dick
Acrylics on Crescent board
23x18ins (58x46cms)
Harper Collins
Wraparound book cover 1990

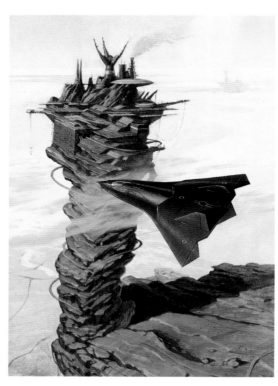

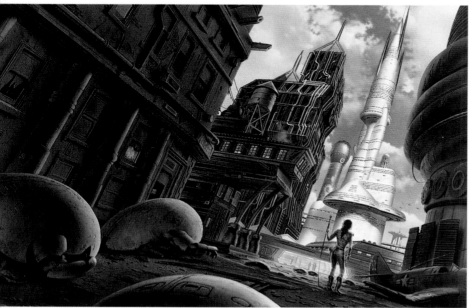

Tell me a little about the building we're in.

It's a purpose-built garage and studio.

So there was never any building here before?

On the original plans of the barn I think there was probably a bit of a lean-to, like an outhouse or something.

Just looking around this end before we move up to your main working space . . . this part is an area which you largely use as a photographic studio, is that right?

Yes. I've got a studio flash unit with four basic lights and a five-by-four camera on a tripod. I have 35mm cameras as well. It's all stuff I've acquired over the years.

You didn't go out one day and decide you were going to be a photographer as well as an artist? It's just stuff you picked up as you needed it?

Well, I found the five-by-four camera in a place in Tunbridge Wells where they were flogging it off cheap because nobody wanted it, so I got that for a very reasonable price.

This five-by-four camera, it's basically a bellows camera with . . .

Just a pinhole camera with a lens at one end and a frame for the film at the other end. The business part is the lens, that's the expensive part of it. Although the camera's expensive anyway.

What kind of lens is it?

300mm Apo-Ronar. I've got a few lenses, but the others I very rarely use. The Apo-Ronar gives you no distortion when you're photographing flat artwork.

No spherical distortion?

That's right, so it's good for reproduction purposes. You get no distortion at the edges of the frame.

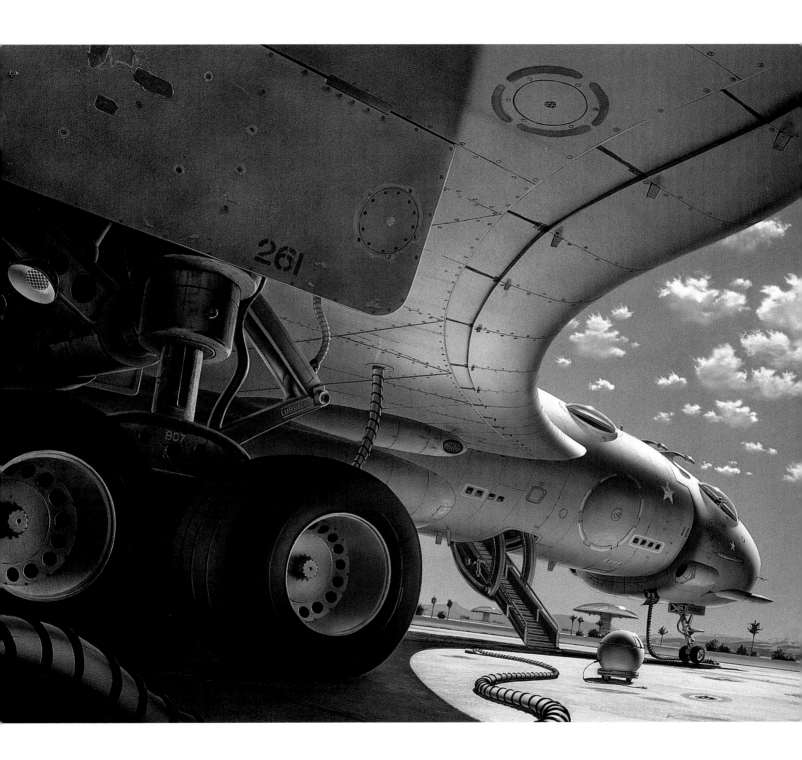

Right:
Subterranean Gallery
Richard Paul Russo
Acrylics on Crescent board
10x15ins (25x38cms)
Grafton Books
Paperback cover 1986

So, as well as doing portrait shots to use as reference for the paintings, you also make your own copy shots of artwork?

That's the principal reason I bought it. A high-resolution five-by-four transparency gives me a permanent record of what I've produced. As the years went by I began to realize there was a certain market in sales of second rights, so making the record was just an essential part of the business. It's OK if you're working in a town, because you can invariably find a photographer who can do it for you. But, if you want to work out of town, then you have to be a bit more self-sufficient.

So what are you working on at the moment, then?

It's not a science-fiction cover.

That doesn't matter. I just want you to give me an idea of how you'd proceed with any picture. Talk me through the various stages of development.

Well, my starting point is a print of the rough that I did on the computer downstairs. I'll make a photocopy of that, blown up to twice the size. I can show you.

Then what? Do you transfer the image by making a grid, or . . .

It's very straightforward. See. I just enlarge the rough onto tracing paper.

You've placed the rough on the photocopier plate and you're feeding a big sheet of tracing paper through it. This is a colour photocopier, is it, or just black-and-white?

Black-and-white. I enlarge this to the intended size of the finished artwork, and then I'll roughly trace it down onto the board. Then I'll re-draw the whole thing, using my reference to tighten everything up.

Right. I didn't realize you could run tracing paper through a photocopier.

You can't. It usually jams!

I see it comes out all wrinkly with the heat. Yes, that's done it. It's quite impressive.

Above:
The Sirens of Titan
Kurt Vonnegut
Acrylic on Crescent board
10x16ins (25x41cms)
Orion Books Masterworks
series
Book cover 1999

The Centauri Device

Jim Burns did a cover for *The Reality Dysfunction* which included a style of trailing explosion that I quite admired, so I pinched it for this.

Left:

The Centauri Device
M. John Harrison
Acrylic on Crescent board
10x16ins (25x41cms)
Orion Books Masterworks series
Book cover 1999

Far left:

Reckless Sleep
Roger Levy
Acrylic on Crescent board
13.5x21ins (34x53cms)
Orion Books
Hardback cover 1999

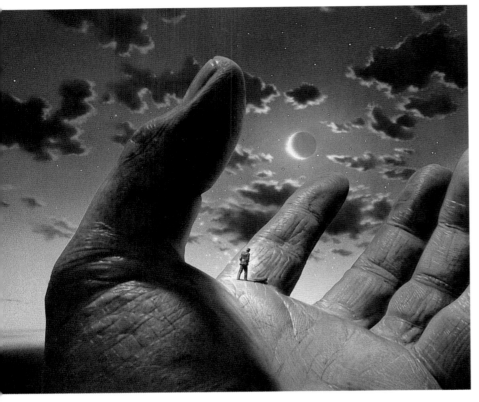

Above:
The Cosmic Puppets
Philip K. Dick
Acrylic on Crescent board
20x15ins (51x38cms)
Harper Collins
Book cover 1995

Far right:
Clans of the Alphane
Moon
Philip K. Dick
Acrylic on Crescent board
22x15ins (56x38cms)
Harper Collins
Wraparound cover 1996

The Cosmic Puppets

'I was trying to come up with an image for the story, which involves miniaturized versions of people being carried around by characters in their pockets. Then I looked at my own hand and I thought, Wouldn't it be incredible if you had a tiny figure walking through this canyon of fingers? So I set up some dramatic lighting and did a quick sketch, and then I produced the finished artwork from that.'

Well, you can start to see how the bones of it are appearing.

So the blown-up rough includes the lettering and everything else, but you're just going to concentrate on the image from now on?

Yes, that's right.

Now we're taking the enlarged tracing-paper rough and moving over to one of the drawing boards. Is there any reason why you have two boards?

Fred Gambino came up to work on a project with me and we needed another, so I brought this one in. I've had it since way back. Now I use one for clean work, like drawing, and the other for painting and spraying, so I keep the two halves of the process separate.

So the technicolour one is the one where all the mess goes. The other board is comparatively unmarked.

That's right. When I had one drawing board, I used to just clean up after every job. But with this arrangement I don't need to. I just . . .

Live in squalor!

Yes, well, you clean up after yourself every year or so.

Space is quite important for someone in your line, isn't it? As well as the boards you've got those two huge tables either side of the room, another table there . . .

I'm spoiled here, I really am. There's a photograph of one of my old studios in a book somewhere downstairs. That place was about one-third the size of this.

Which studio was that?

The one I had when I lived down in Kent, just after I'd moved out of London. Then for eight months, when we first moved up here, I worked in the living room of the bungalow that we had down at the hospital. Every evening I had to fold my drawing board away and put it up against the wall. All my photographic lights and everything, all had to be put away. It was a nightmare.

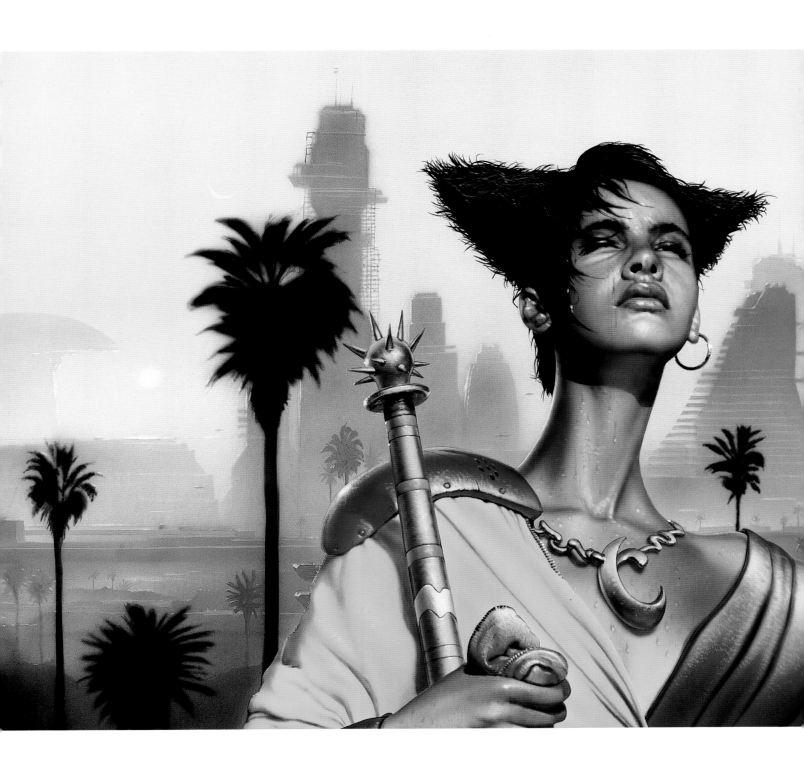

Colony
Ben Bova really liked this one. I met him when he came over for the 1979 Worldcon in Brighton, and he signed the artwork for me.

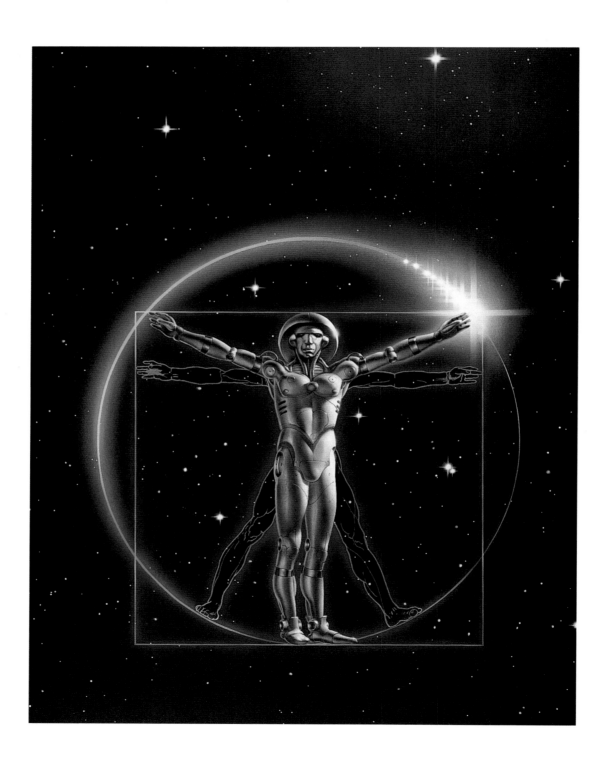

Right:
Encyclopedia of Science Fiction
Acrylics on Crescent board
18x28ins (45x70cm)
Little, Brown
Book cover 1995

Once you've talked me through this part of the process, I want to ask you more about your life in the eighties. I want to know how you came to end up back in the North.

There's a lot about Covent Garden that we haven't even touched on yet. Wellington Street was only the beginning of it. We had two other studios after that first one. One was on Neal Street and the other was in Bedford Chambers.

You've taken the tracing paper and you've fixed it over a piece of artboard with a couple of pieces of masking tape. What kind of board is that?

Acid-free premium line board. Fine line.

And you've masked off the outside couple of inches of the board with — what's that? Parcel tape?

Just parcel tape along each side, which will give a clean edge to the painting. Some artists let the image bleed off at the edges and then put a paper mask over it when they've finished, to make it more presentable. But for me it's part of the thrill when at the end of the job you take the masking tape off and it's there, like a window you're looking through. It makes the whole job look very clean and professional. And I think, to a certain extent, it makes it just that little bit more impressive.

What happens next?

Well, I've got some stuff called Trace Down. It's like very light blue carbon paper. I used to use something similar called Dragon's Blood paper, but they don't make that any more. That gave you a pale red line.

And what do you do? Do you slip that between the tracing paper and the board, and then work over it?

Yes, and it transfers the image down from the tracing paper onto the board.

Well, while you're doing that, let's go back to your time in Covent Garden. Where did you move to after Wellington Street, and why?

We moved to space on Neal Street after about two years.

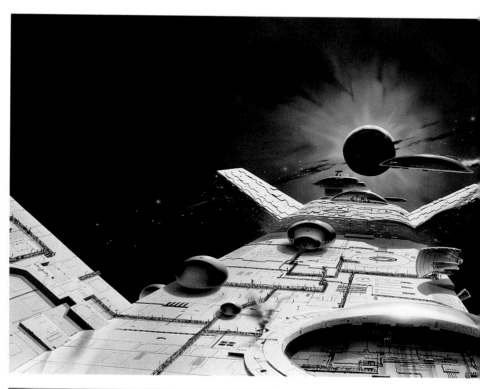

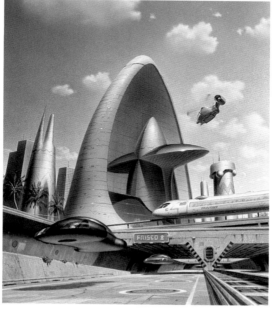

Above:
Colony
Ben Bova
Inks, Acrylic and Poster
colour on CS10 line board
22x15ins (56x38cms)
Methuen
Wraparound paperback cover
1978

Left:
Down and Out in the Year 2000
Kim Stanley Robinson
Acrylics on Schoeleshammer board
10x19ins (26x48cms)
Harper Collins (Grafton Books)
Book cover 1986

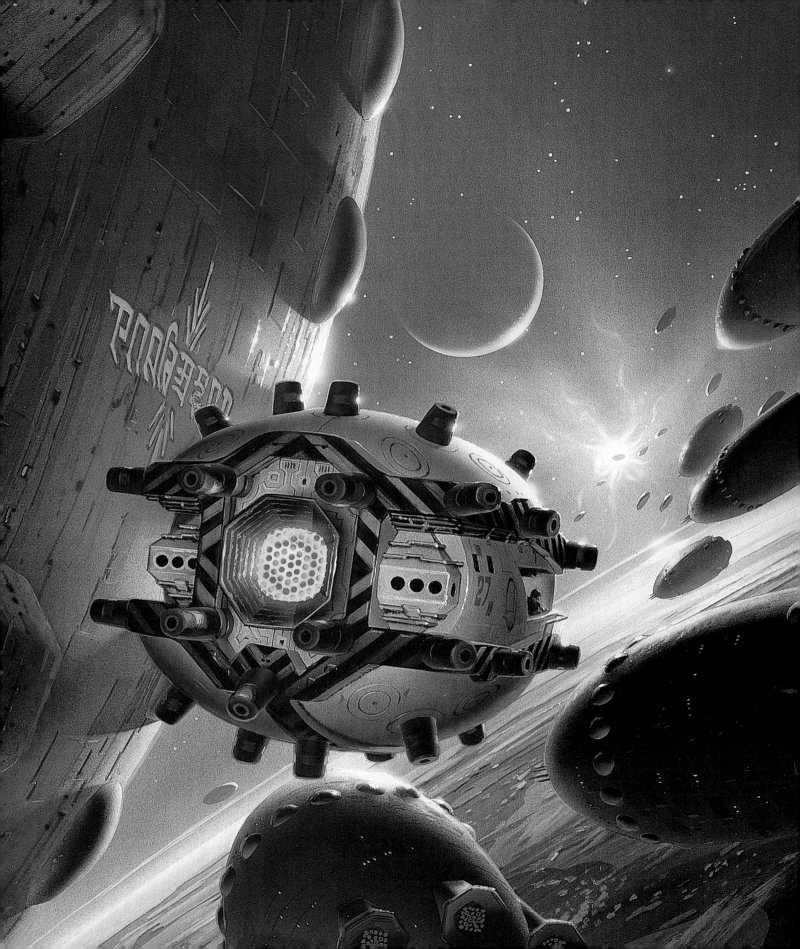

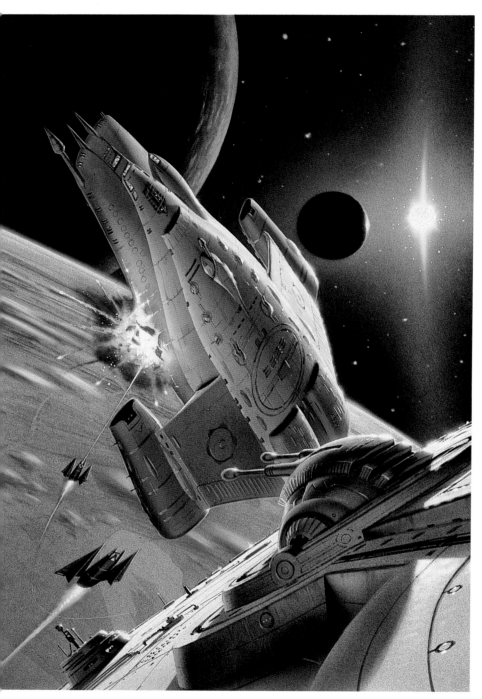

Any particular reason?

It just made sense to move. The whole area was changing, people's situations were changing . . . space became available somewhere else which was better, or people who you were sharing with needed more space, so you moved to accommodate that.

Did the move reflect the fact that you'd started small and you were building the business up?

Not really. We did pretty well from the beginning. I mean, we waded into doing book jackets almost straight away, and because we shared space with another design group we'd get further work from them. It came to us in various ways. We used to get a lot of work from a firm of printers based in Clapham who had the Victoria and Albert Museum as a client. One day their guy – David, I think his name was – came over with these Stubbs prints that he needed to get sized up for an exhibition leaflet. They were worth so much money that the Managing Director at the printers had been keeping them in a bank vault. This guy had picked them up from the bank and brought them over to us. He was all hot and sweaty because he'd parked about a mile away and carried them through the streets, not realizing he could have parked right outside because there were no restrictions around the market. Mick was dealing with him over on the other side of the office, and the prints were on my desk. So I picked up a piece of scrap paper and said, 'These are really nice-looking prints. How much are they worth, David?' And he said, 'Oh, £50,000 apiece.' I said, 'It's really thick paper, isn't it?' and then I made a noise as if I'd stumbled or something, and I went RRRRRIP! with the scrap paper. He just went rigid in his chair and didn't move. Then he turned around really slowly, and as he turned I could see that his glasses had steamed up!

Did you ever get any more commissions from them?

Yes, he took it in good part, bless him, but I think it took ten years off his life!

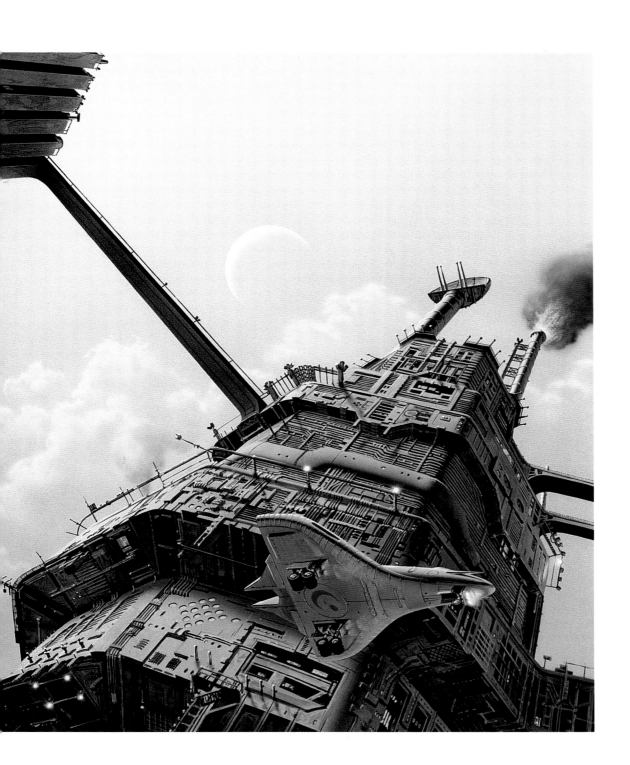

Previous page:
Penumbra
Eric Brown
Acrylic on Crescent board
22x15ins (56x38cms)
Orion Books
Wraparound book cover 1998

Left:
Second Variety
Philip K. Dick
Acrylic on Crescent board
20x15ins (51x38cms)
Harper Collins
Wraparound cover for
Volume 2 of Philip K. Dick's
short stories 1993

Far left:
The Buchanan
Campaign
Rick Shelley
Acrylics on Crescent board
10x15ins (25x38cms)
Ace Books
Book cover 1995

So when you moved to Neal Street, was it as trendy then as it is now?

It was going that way. It was certainly the place to be if you were involved in design. There were loads of illustrators around, and designers and photographers. A photographic library took over one of the warehouses that had been vacated due to the market being moved, and before the place was converted they decided they were going to have a huge shindig in this cold store in the basement. Essentially it was a party in a giant fridge, and it was a good one. I got completely rat-arsed, and ended up with this young lady. The only thing I could remember afterwards was that she was some union official at a well-known publishers, which shall remain nameless. And we tried doing the dirty deed in the warehouse at the back, but that was unsuccessful, so we ended up going back to my place. The next morning I got a cab for her and she left, and I didn't see her again.

Almost a year later they'd completed the conversion work on this photographic library, and Mick and I were given a guided tour of the place by the proprietor, who shall also remain nameless. And as we walked into one of the rooms, there was this girl sitting at this table working at a light box, and the chap who was showing us round said, 'Oh, I don't think you've met, have you?' I said 'Yes' and at exactly the same moment she said 'No'. I thought this was very strange. I didn't say anything until we'd got out of the room and then I turned to him and I said, 'She's a lying sod. You know the fridge party that you had? Well, her and I ended up back at my place bonking on the sofa.' And he said, 'That's my fiancée you're talking about.'

There's no graceful way out of a situation like that.

There are so many stories from around that time. We had all sorts of strange characters wandering about Covent Garden. One day we had a man just burst in through the door and set fire to himself with lighter fuel. After he'd been burning for about ten seconds, he produced this fire extinguisher out of his pocket and put himself out, and then tried to sell me the fire extinguisher for the office.

Right:
Now Wait for Last Year
Philip K. Dick
Acrylic on Crescent board
22x15ins (56x38cms)
Harper Collins
Wraparound cover 1996

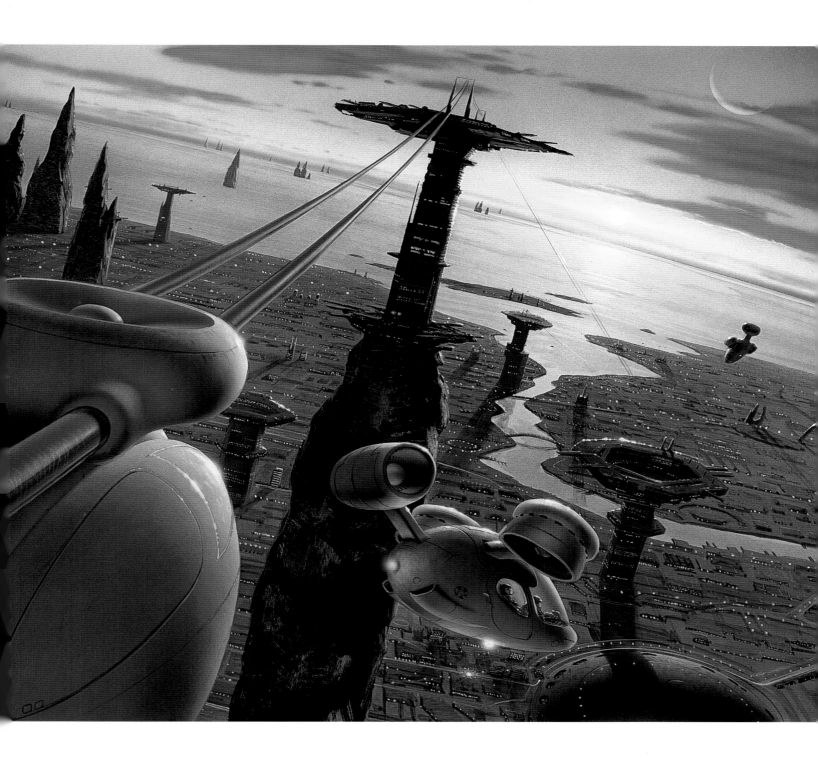

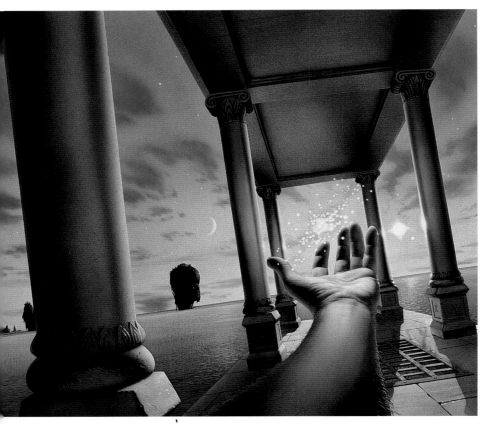

Above:
Valis
Philip K. Dick
Acrylics on Crescent board
15.5x21ins (53x40cms)
Harper Collins
Another 'hand' picture
Wraparound book cover 1993

Far right:
The Complete Asimov
Isaac Asimov
Acrylics on Crescent board
18x15ins (46x38cms)
Harper Collins
Two covers in one painting
for the two volumes of short
stories 1989

What are the biggest differences between the scene as it was then and the way things are now?

I was on the committee of the Association of Illustrators, and we had a lot of problems dealing with the print unions. They set up a scheme to recruit new members for their organization, and their idea was basically to blackmail people by depriving them of the window for their work. Your work couldn't be printed unless you belonged to this union and had an official number which had to be stuck on the back of every piece of artwork that you produced. You'd see newspapers with blank spaces where an ad. should have appeared, because the source of the ad. was a non-union house. All the agencies were joining, all the publishers, a lot of the design groups, and for no other reason than that it would hurt them not to.

If you did join this union, Slade, you went into a separate division called Slade Art. In Slade Art you had no voting rights, you couldn't stand on the union executive, you had nothing, you were just a number. It wasn't a real membership. They wouldn't defend you in court if you had to sue somebody over copyright infringement or for non-payment of invoices, and they couldn't guarantee you a minimum wage or holidays. There were no perks, no benefits at all. The sole reason for the whole activity was to recruit you as a member in order to boost their numbers and make them more powerful.

And they tried it with us. They tried everything they could to get us to join the union, and we flatly refused. One firm of printers rang up to say, 'We've been told we can't supply you with typesetting unless you join the union.' So I just said, 'Well, sorry, we'll get our typesetting somewhere else. Nice doing business with you, thanks a lot, 'bye.' Ten minutes later the phone rang again. My partner, Mick, answered it, and I heard him say, 'So what union does your accounts department belong to?' Obviously they were chasing us for the money that we owed them. The reply came back from them: 'Well, they don't belong to any union.' And Mick said, 'You can't expect us to pay you if you don't belong to the union,' and put the phone down. At which point they phoned back and said, 'We'll do your typesetting for you and we'll give you a load of stickers as well, so you can get your work printed.' So we were quite happy, really. We had a big roll of stickers.

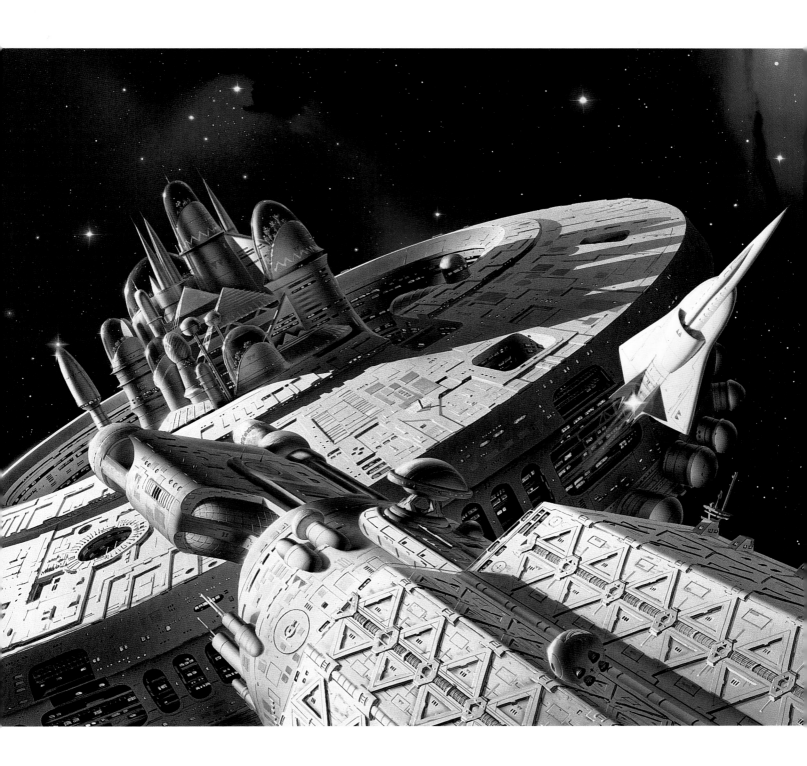

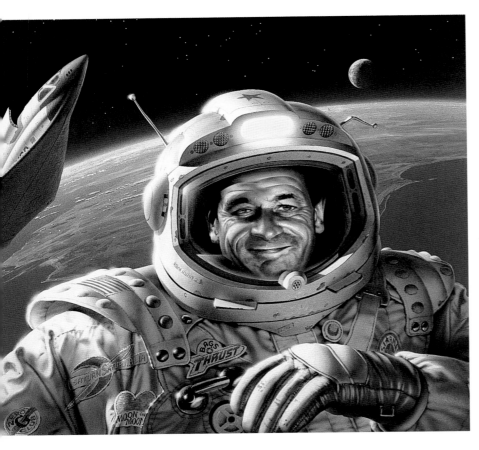

After Neal Street, Bedford Chambers? Where's that?

Above:
Sam Gunn Unlimited
Ben Bova
Acrylic and inks on Crescent
board
20x15ins (51x38cms)
Methuen
Wraparound paperback and
hardback cover 1992

Far right:
The Unteleported
Man
Philip K. Dick
Inks on Schoeleshammer
board
22x16ins (56x41cms)
Methuen
Wraparound book cover for
1977

The studio was on the third floor of a building that's now the Rock Garden Café, adjacent to the market square right in the middle of Covent Garden. From our window you could see across the rooftops to Floral Street Dance Studios. One very sunny evening there was an impromptu concert being given, with some bloke playing the piano in there to a group of about twenty people. It didn't sound particularly good, so we thought we'd contribute with 'The Ballad of Davy Crockett' blasting out of a hi-fi across the roof, at which point the concert promptly came to a close. A couple of minutes later André Previn strolled out with a glass of wine in his hand, and gave us a very nasty look.

But apart from pissing off major musical personalities, you remember it as a happy time?

There was always something going on. There was a paste-up artist in our studio named Tony Chalfont, and his pride and joy was this black Mini that he'd saved up all his pennies to buy. We played a very nasty trick on him and stuck a crumpled-up black plastic bag to the front wing, so that it looked like somebody had crashed into it. I had a Range Rover for a while. On the night of Pete Bennett's leaving do, ten of us crammed into it and we drove off without realizing we'd left his cake on the roof.

Just to return to what we're doing here, for a moment. You're going over the tracing paper rough, and you're transferring the image down onto the board with the Trace Down paper. So how rigid a guide is that going to be?

It will be very rough, very rough. This tool that I'm using is a stylus from an old Gestetner printer. It's just a pointy bit of metal with a handle on it. And I'm just going around the lines of the image roughly, putting in detail where I think I need to. When this is done I'll take the tracing paper off and I'll have a pale blue copy of the image, faint on the white board. Once I've got that, I'll then work back into it with pencil, tightening the whole thing up and redrawing it using the blue-line image as a guide. And that drawing then becomes the basis for the illustration. So at any stage through this process, you can change things, you can move things, you can enlarge them, reduce them, re-draw them, re-angle them. You can draw into it as much as you like.

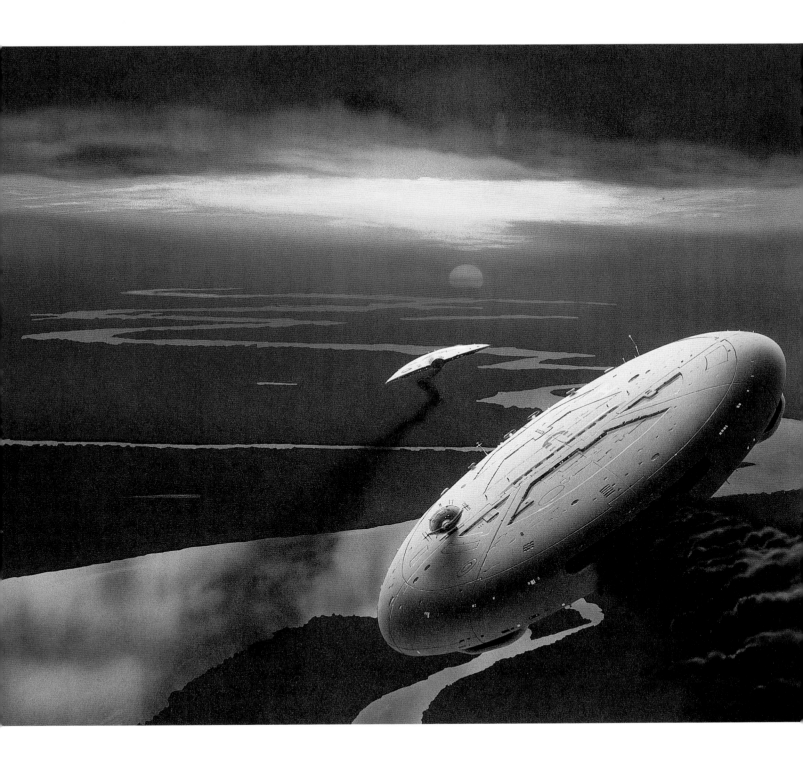

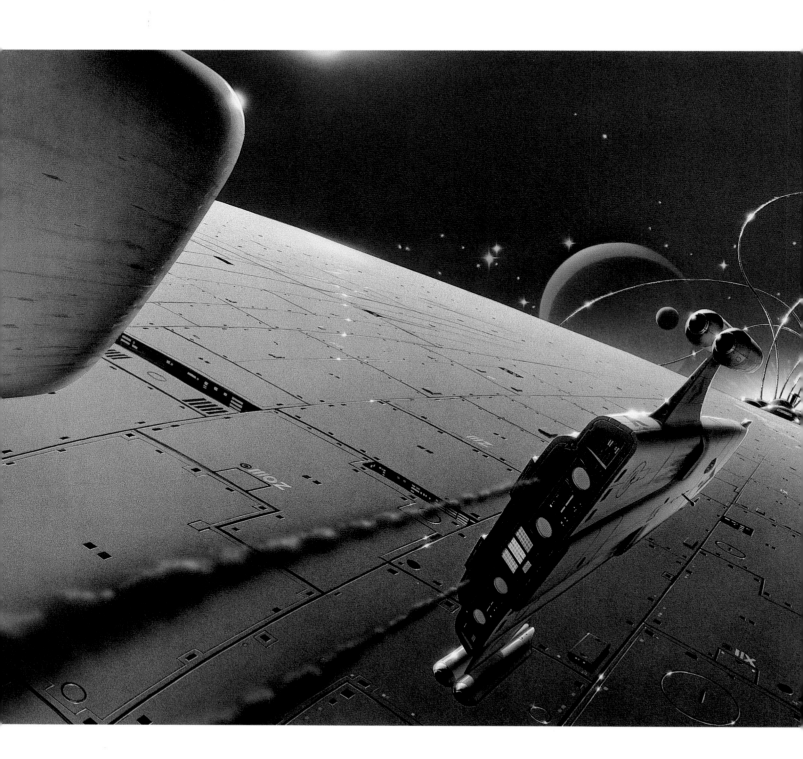

How tight will the pencil drawing be compared to the paint you're going to put on?

Well, it'll be pretty tight, but then there's a further process where you can tighten it up even more so. When I've got the drawing as tight as I feel I need it to be, I'll apply this masking material called Frisk Film and use the drawing underneath as a guide while I cut out specific areas from the film to work on. Does that make any sense?

I think so. Frisk Film's the stuff you use to mask off the picture when you're airbrushing?

Quite often I don't use the airbrush at all. It's just another tool, and for a long time I resented people saying, 'We want an airbrush drawing of this, or an airbrush picture of that.' I mean, I use an airbrush, but I also use brushes, I use rags, I use pieces of paper, I use all sorts of techniques for applying colour.

And masking lets you use these techniques side-by-side without the work on one area affecting another?

Yes. It can almost be like painting by numbers. The trick is to make all the areas of the picture interrelate, so that they look like something coherent rather than just a series of little bits. And I think that's where the skill is, really. Having the idea in the first place, and then bringing all the necessary elements together to make the cohesive picture you imagined.

I suppose, in order to be able to do that, you've got to be able to hold the entire end-product in your head. It's going back to what you were saying about visualizing the completed brick wall and then going through all the stages to get to it.

Yes.

But you have to be really on top of it in order to be able to do that, don't you? You have to be able to imagine the end-product in all its detail, and then know what you have to do 20 steps back in order to finally get there.

Yes. Over the years you learn how to structure what you're going to produce.

Far left:
Starbridge
Jack Williamson and
James E. Gunn
Inks and Acrylics on line
board
20x15ins (51x38cms)
Methuen
Book cover 1979

Left:
Agent of Destruction
Rutledge Etheridge
Acrylic on Crescent board
9x14ins (23x35cms)
Ace Books
Paperback cover 1993

Below:
Down Below Station
C. J. Cherryh
Inks and acrylics on CS10
20x14.5ins (50x36cm)
Methuen
Paperback cover 1980

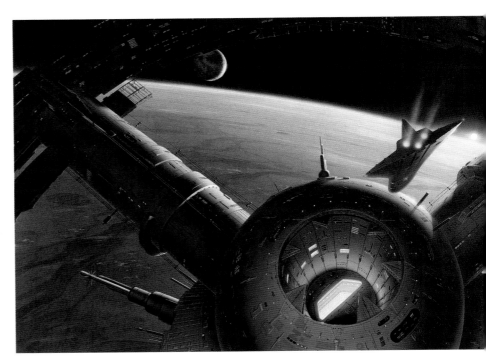

What's your preferred medium? On the table alongside the drawing board here, apart from a bowl of water about the size of a small fish tank, you've got dozens of small jars of acrylics. Are acrylics your main medium?

I used to use inks, but the colours are fugitive.

Does that mean they don't last?

Yes. They're not permanent. Unlike acrylic paint, which is. In the early days, when I wasn't involved in selling paintings, permanence didn't really matter. The work went straight to the printers, and if you needed a record you kept a transparency.

So you only cared about it lasting long enough to do its job?

Yes. Maybe this is why I'm not precious about what I do, because a lot of what I produced way back has disappeared. Or, rather, bits of them have disappeared, because some colours are more fugitive than others. I once did some Christmas stamps for what was then the Spastics Society. One was a snowman in a field, all pale blues and greens apart from his nose, which was bright red. I did the bright red nose in gouache, which is light-fast, and the rest of it I did in inks. I had this one framed up and gave it to my parents as a Christmas present. They put it in their conservatory, and within six months the whole thing had disappeared apart from this red nose! So visitors would say, 'Oh, your son's an artist, is he? Is this one of his?' And there's a red nose in the middle of a blank sheet of paper.

A snowman in a snowstorm!

But nowadays I use these acrylic paints. They say they're permanent, and I haven't had any complaints about them fading. They've been around for 30 or 40 years now. There are all sorts of schemes that people have devised to try and protect delicate paintings. You can put them behind ultraviolet-filtering glass. I've even got some stuff in these cupboards somewhere which you're supposed to be able to spray on, and that acts as an ultraviolet filter as well. It's the UV light that destroys the pigment, but I don't think any of those things work. I can't see there's any way of stopping it.

Right:
Do Androids Dream
of Electric Sheep?
Philip K. Dick
Acrylic on Crescent board
22x15ins (56x38cms)
Harper Collins
Wraparound cover 1993

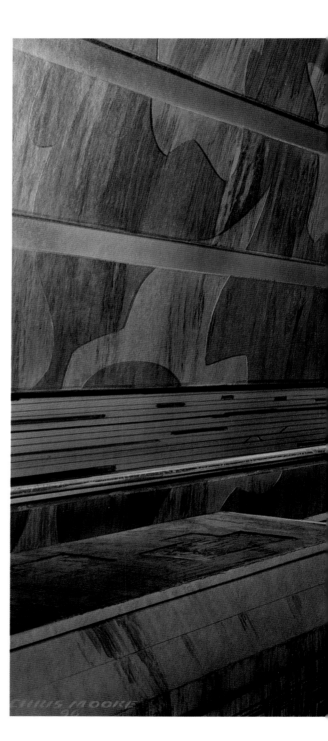

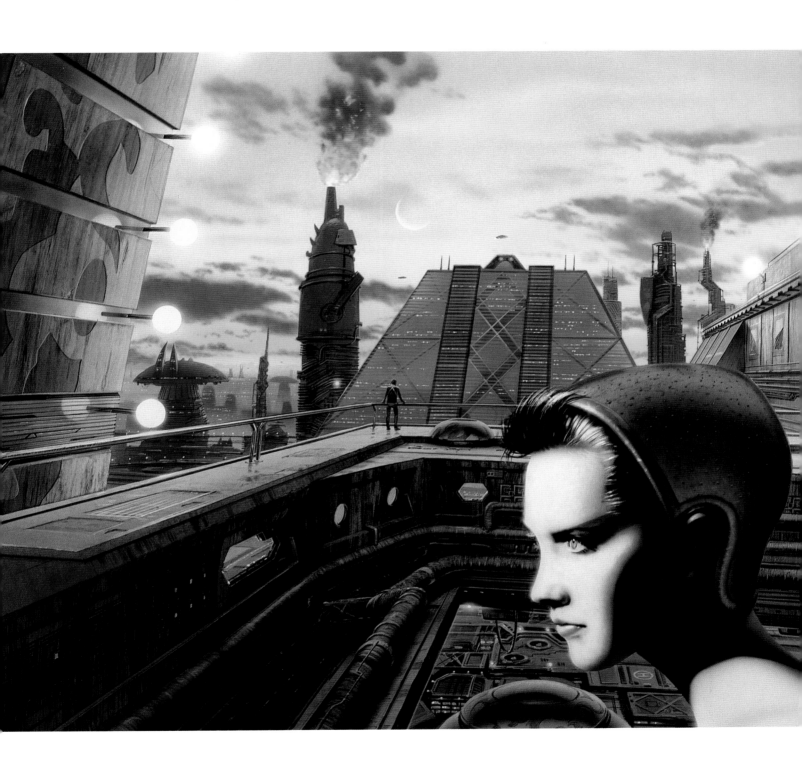

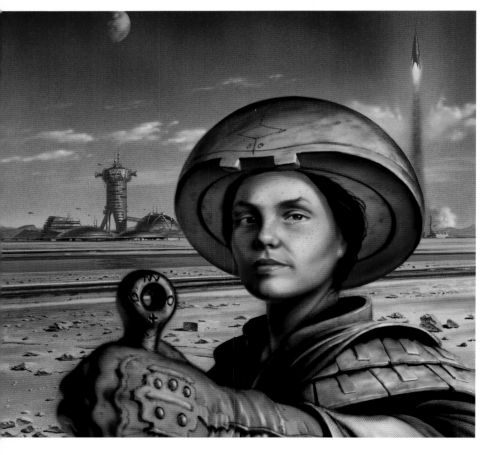

Above:
Martian Time Slip
Philip K. Dick
Acrylic on Crescent board
10x16ins (25x41cms)
Orion Books Masterworks
series
Book cover 1998

Right:
Grounded
Chris Claremont
Acrylic on Crescent board
10x16ins (25x41cms)
Pan Books
Paperback cover 1985

We talked before about how you put in eight years with the design group and then finally made the move out of London when you got married.

Well, after the marriage ended I was on my own and working out of the house I had in Kent. Then Katie and I met on holiday in Lindos. She was in Manchester at that time, a Senior Registrar. Once we'd met and the ball started to roll, we decided we wanted to be together. She got her professor to contact his opposite number in London – I think it was at Guy's Hospital – to see if it would be possible to arrange a rotation down south to finish her consultancy training, which is very unusual. But in view of the circumstances, us wanting to be together, they approved it. So she finished her training at a hospital on the south coast in Brighton, which was a fair old haul from where I lived.

But closer than Manchester.

That's right. But in the first year she came down to Kent from Manchester at least three weekends out of every month, either on the train or in the little Ford Fiesta that she had. It's quite incredible, really, when you think about it. In that whole period I went up to Manchester about three times. That's really due to the nature of my work. It spills over into weekends all the time, it always has and it always will. Once she'd qualified she became a locum consultant in Brighton, and they eventually created a post for her there.

But you didn't stay.

It was Christmas and we were just leaving the Anaesthetics Christmas party at the hospital. We were talking about whether she should take up the post. My comment was, 'Well, we can live here if you want, it's totally up to you, I can work anywhere, but Brighton's full of weirdos.' And right at that moment this guy appeared from behind a car in the car park. He was dressed in buckskin and he was wearing a headband, and he had a bag of chips in his hand. He wasn't very steady on his feet, he was weaving all over the place. He held out the bag and said, 'Hey man, want a chip?' I said, 'No, thanks,' and he wandered off into the night. After what I'd been saying, it was right on cue.

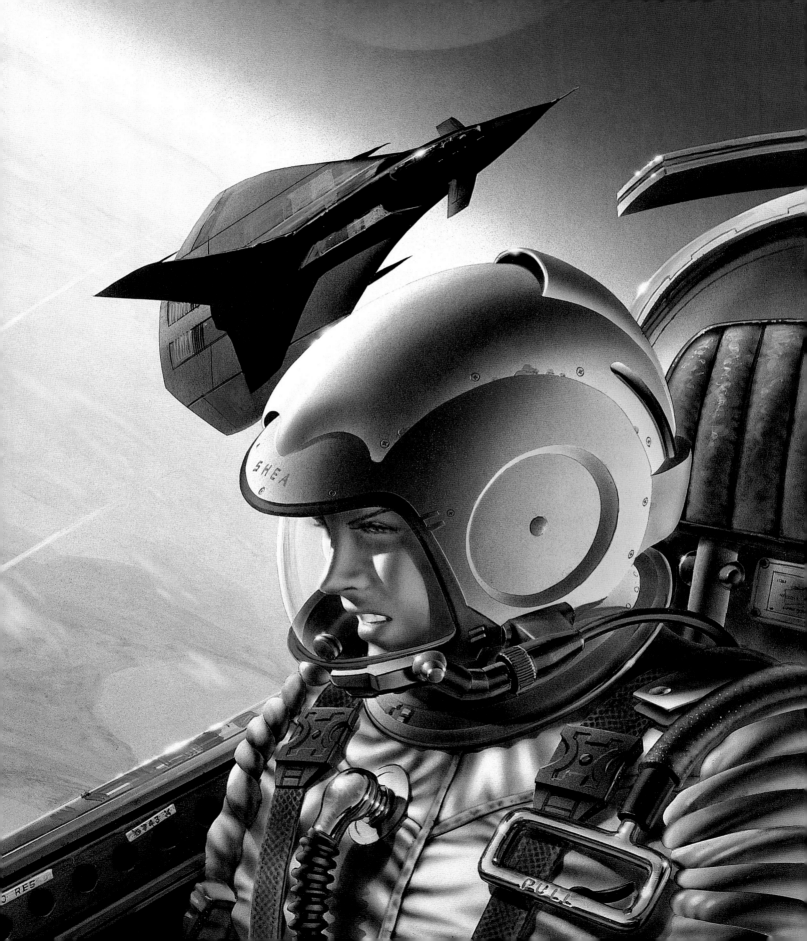

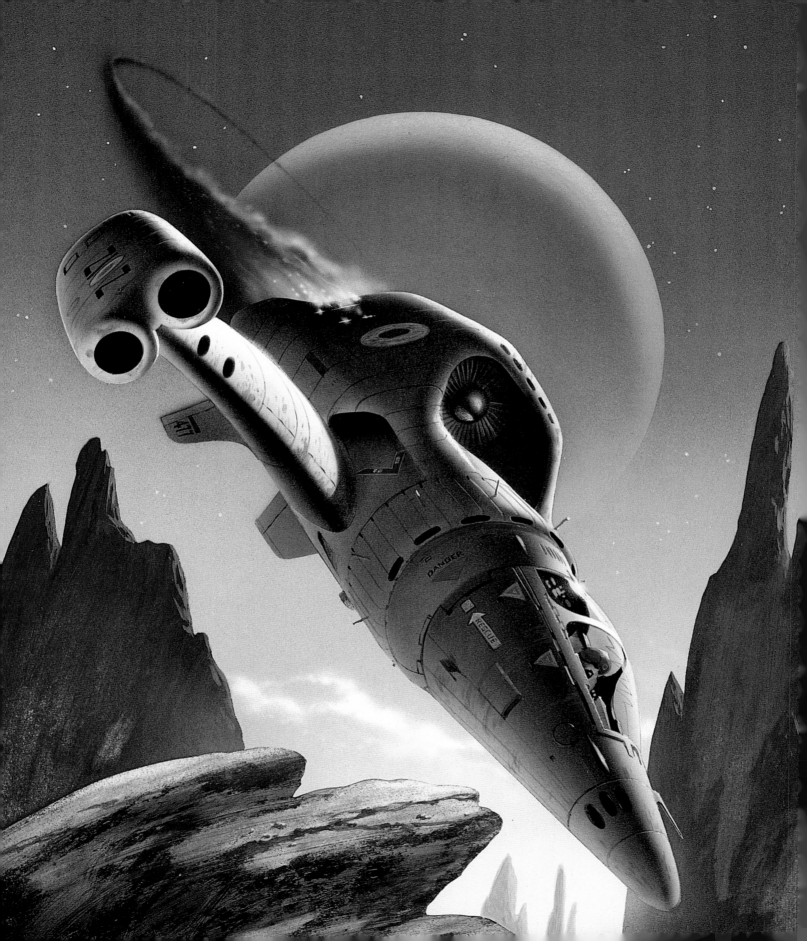

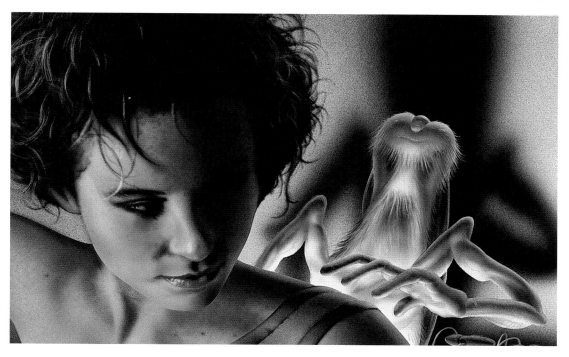

The Weight
Rights on this were sold twice for two completely different books and they came out at about the same time. Fortunately the companies concerned were sanguine about it. At the time I had no effective way of keeping track of second rights. This was one of the things that prompted me to set up the database of my work.

So did she apply for jobs elsewhere?

This one came up in Burnley. I knew a little bit about the area because I'd done some wallpaper designs for Coloroll, which is in Nelson, just a few miles away.

Wallpaper designs?

Character wallpaper for *The Empire Strikes Back.* When I'd driven up here for meetings I'd been impressed with the countryside. We thought, Well, we'll go and have a look, go and see what it's like. When we came up here we both loved the place, so she applied and got the job. I told you that we lived in hospital accommodation for a while. We bought the barn as a derelict shell and lived in the hospital bungalow while the builders were working on it. That's how we finally came to be here.

OK, let's turn our attention back to what we're doing on the board here. We've traced, we've transferred, we've masked, we've painted. We've followed the process up to a high level of finish now. Is there anything you need to say about that in terms of technique, or . . .?

Usually I'll apply large areas of colour, with an airbrush or with a brush or with a rag or whatever, to the masked-out parts. Once that's done, you've laid out the basic structure of the way the thing's going to look. You don't have the detail yet, but you have the important relationships of the shapes and the light and the shade and a sense of the range of colours. It's almost like an underpainting. The old masters used to do an underpainting, and then work on top of it. I do a very similar thing, really, and then I work on top using either a brush or fine airbrushing. And then to pull the whole thing together at the end, I'll work over it with a final film of paint. Thin paint, to balance it tonally.

In the same way that the Old Masters used to add glazes to build depth into a picture . . .

Yes. They used thin glazes of oils and it could be a long process, but with fast-drying acrylics it's very quick.

Above:
The Height of Intrigue
Stephen Godin
Acrylic on Crescent board
11x15ins (28x38cms)
Analog Magazine *cover*
1994

Far left:
Cover for a book by
Clifford D. Simak
subsequently used for
The Weight
Allen Steele
Inks and Acrylics on
Schoeleshammer board
10x19ins (26x48cms)
Legend Books
Hardback cover orig. 1983,
The Weight *1994*

Speed is obviously a big factor in the way you have to turn a painting round in a certain number of days and deliver it. Presumably that militates against using oils.

That's why acrylics are the preferred medium for a lot of people. Which is not to say that I don't like working in oils, because I do.

Do you bring the picture to a point where you're a hundred per cent satisfied with it and then send it off, or do you send out sometimes feeling, Well, this is a provisional stage, let's see what they say?

It depends. I have to say that I never send anything out that I'm a hundred per cent satisfied with, because I'm never a hundred per cent satisfied with anything. But then you can reach a point where you look at it and you think, well, once that's reduced to the size of the cover, then it's going to tighten up and will look right. I know, through the experience of doing this for such a long time, the level of finish that is required.

So what happens then? How do you deliver the work to the client?

Well, first I take transparencies. If it's something I'm particularly happy with, I'll take four. If it's something that I'm never really going to see again, then I'll just take a couple in case it gets lost.

These are the five-by-four transparencies that can be used as printing masters?

Yes, and they're your insurance against some of the horrendous things that can happen to your work in transit. A guy called Mike Terry had one of his run over by a train. The clients received this picture with a Z-shaped fold in it where the train wheels had been. I've had things lost and stolen as well.

You say you like to paint in oils when the opportunity arises. How often does that happen?

I get asked to do them now and again. I always feel that oil painting has an integrity about it. There's been a long history of oil painting throughout the ages, and these days that tradition seems to be very much alive in America. When I went to a Worldcon in Baltimore a couple of

Right:
Millennium
Ben Bova
Acrylic on Crescent board
22x15ins (56x38cms)
Methuen
Wraparound cover for paper-
back and hardback 1987

Picture overleaf far right:
The Rediscovery of Man
Cordwainer Smith
Acrylic on Crescent board
10x16ins (25x41cms)
Bookcover for Orion Books
Masterworks series 1998

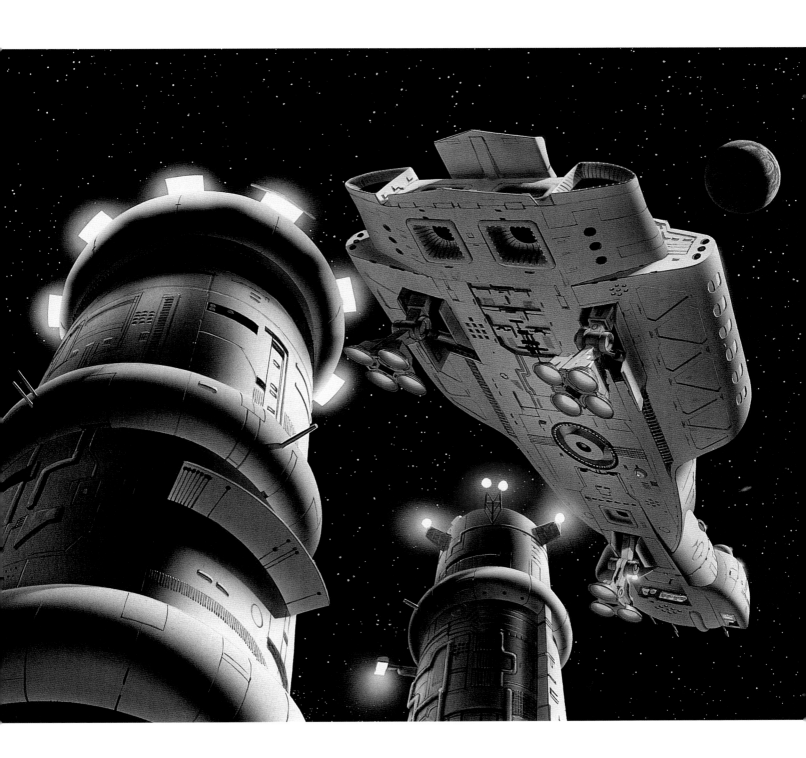

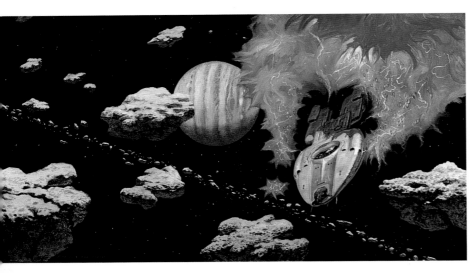

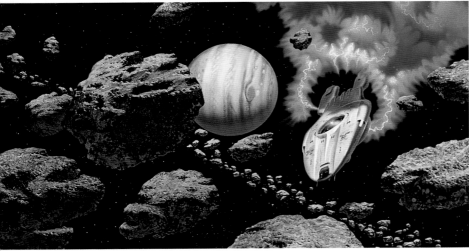

Above:
Bloom (in oil)
Wil McCarthy
Alkyd and Oil on Masonite
28x20ins (71x51cms)
Orion Books
Wraparound cover 1999

Bloom (in acrylic)
Wil McCarthy
Acrylic on Crescent board
20x15ins (51x38cms)
Orion Books
Wraparound cover 1999

years ago, I was very impressed by the way the American artists work. A lot of them work in very traditional ways, irrespective of what they're actually producing in terms of imagery. Many of their techniques are the same as those of the Old Masters.

That's strange, because you'd expect it to be the other way around – you'd expect them to be at the forefront of whatever new technology was coming in, and you'd expect the Europeans to be the ones who were doing it the old way.

Yes, and that really impressed me. When I appeared on a panel in Baltimore on various aspects of illustration, my throwaway attitude to it seemed to be a complete anathema to the people I was talking to. They obviously have so much reverence for it, compared to people in Britain. And I came back thinking, Well, I'm going to do some of this, not least because I really enjoy slapping paint about – that's one of my favourite phrases for describing what I do. So I sat down to produce a picture to order for Orion, and much against the advice of my agent I insisted on doing it in oils. I delivered this painting which I was really chuffed with, because I felt that I'd pushed at a few boundaries and I'd learned a lot doing it, and it came whizzing back. They said, 'We don't want this, we want an airbrush picture.' So I did it again.

I've still got the original painting here, which I much prefer. I had allowed myself to be seduced into thinking that I might be regarded by publishers as something more than a service to their industry. I'd started to think that I might be an entity in my own right, and I was quite sharply rapped across the knuckles for it. It was a case of, 'Get back to the drawing board and do what we want!'

Get back in your box, Moore!

But I still do things for myself. That thing over there, when I find time.

This is an unfinished picture of a space shuttle in earth orbit. The painting's very loose, very bold. So it's not a commission, it's just something you're doing for your own satisfaction?

Yes.

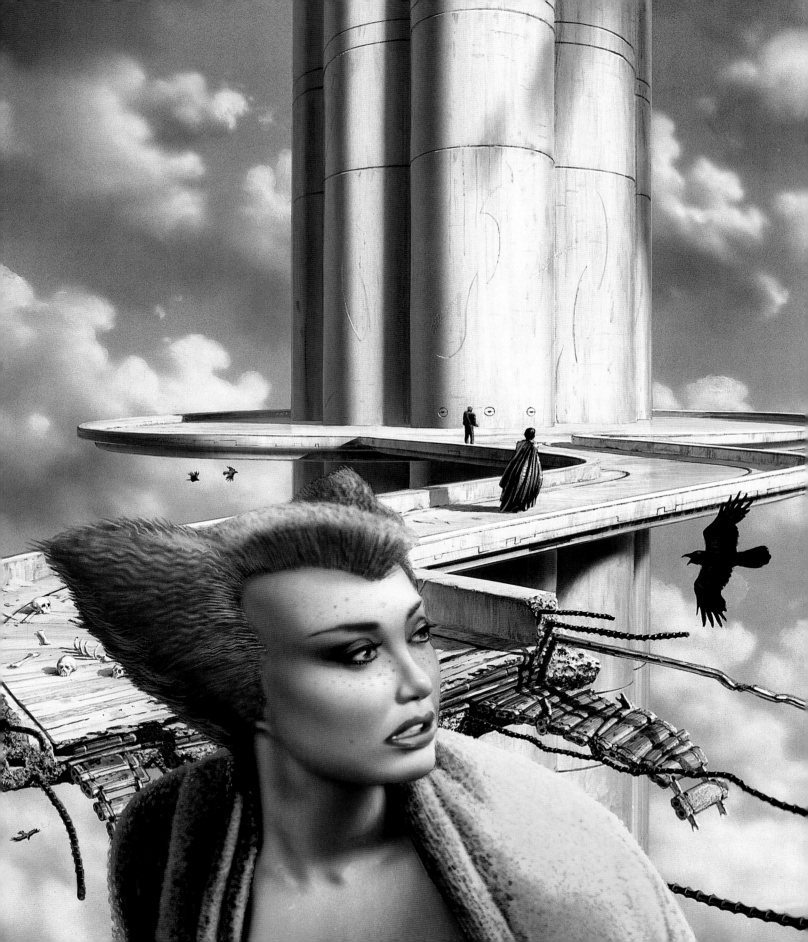

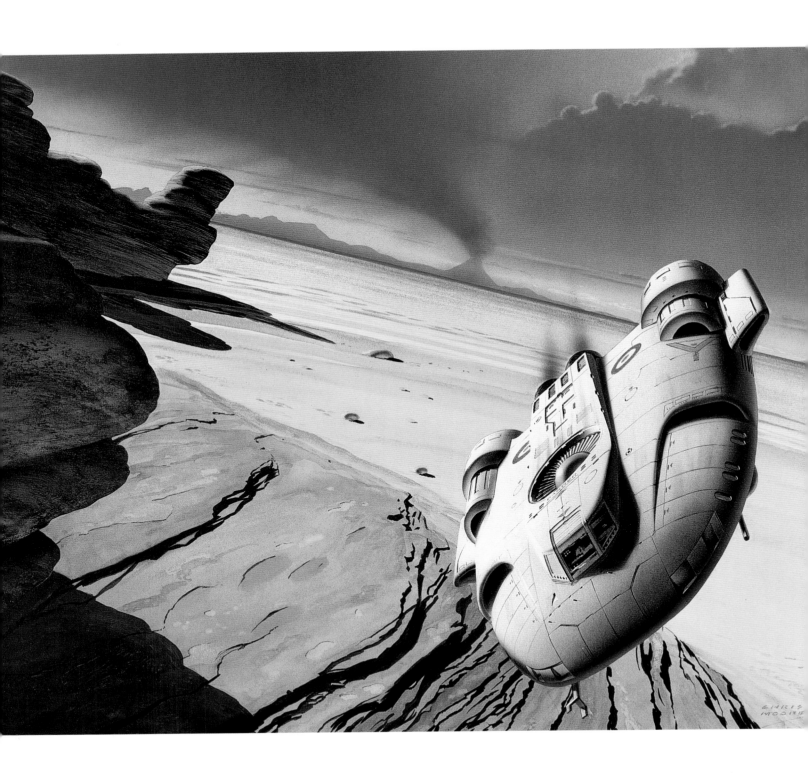

So in terms of the development process we've been talking about for your book covers, what stage of production does it represent?

That picture is being executed in a completely different way. With something like that, you prepare a board and you just draw straight onto the board, and you keep changing the drawing until you feel you've got that right, and then you start painting. At no stage throughout either process is there any comparison.

So there you're working as an artist rather than a commercial artist, is that the difference?

Oh, no, it's just a different way of working.

It strikes me that the difference is quite significant. The way you do your cover paintings, where you build up through various levels of rough, to pencil on board, then paint over pencils . . . every stage of that process is accessible to other people so that they can wade in and make comments and ask for changes. Whereas when you work straight onto a board like that, you're answerable to nobody but yourself. Nobody else gets a look into the process.

I suppose so. They're both flexible approaches in their own way, but I think that working directly onto board like that gives you infinitely more flexibility. It's like there's nothing you can't do. You're not restricted by the medium, by the technique. If it starts to become a bit muddy because colours are mixing up too much, then you stop and let it dry and go back to it later, and you just paint over it. You can move the paint around, which you can't really do when you're using acrylics with an airbrush. There you've got to get it right first time. I'm not saying I find either method more enjoyable than the other. I just find it a welcome change.

You say it's just a different way of working. But last time I was here, when I asked you what you would do if you were answerable only to yourself and there were no clients or deadlines, you told me you'd concentrate on more elaborate and involved forms of science-fiction painting. Is this the kind of thing you meant?

Yes, because I'm in love with paint. I'm not getting bored with what I do, but I've been working in the same way for most of the 28 years since I left college. Outside of an occasional

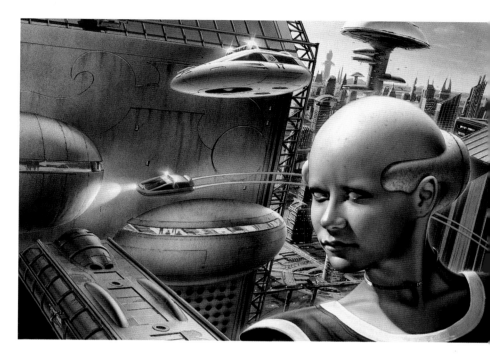

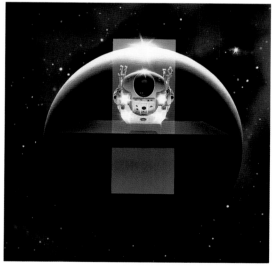

Above:
Resurrection Inc.
Kevin J. Anderson
Acrylics on Crescent board
21x15ins (53x38cms)
Harper Collins
Wraparound paperback cover
1996

Left:
2001
Arthur C. Clarke
Acrylics on Crescent board
17x26ins (43x66 cms)
Little, Brown
A4 Paperback cover 2000

Far left:
The Exiles Trilogy
Ben Bova
Acrylic and inks on Crescent board
20x15ins (51x38cms)
Methuen
Wraparound paperback and hardback cover 1982

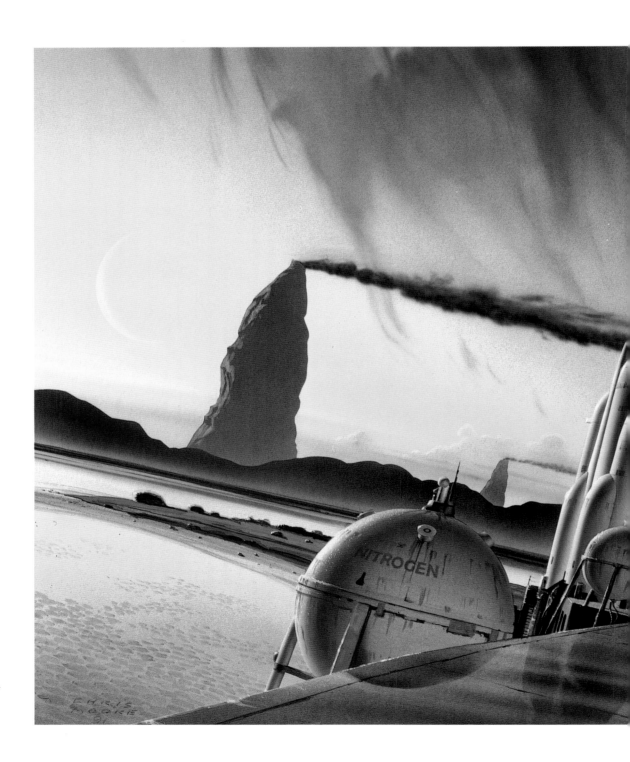

Right:
Ubik
Philip K. Dick
Acrylics on Crescent board
15.5x21ins (53x40cms)
Harper Collins
Wraparound book cover 1992
In the collection of Howard
and Jane Frank

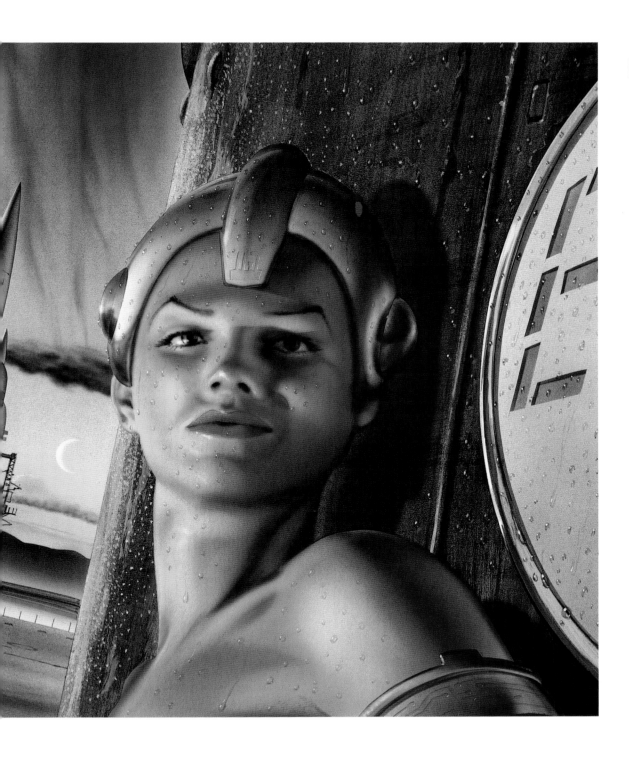

Ubik

With this one I wanted to introduce an air of furtiveness with the figure in the foreground. I read somewhere that Triton, one of the moons of Neptune, has plumes of methane ice erupting in eight-kilometre-high geysers, and that gave me the detail for the background.

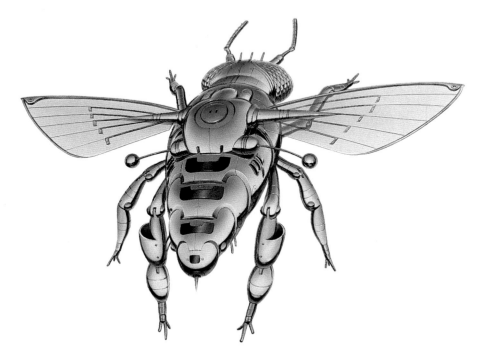

excursion into another medium, there's been no real opportunity for me to get my teeth into something more fundamental. Working in oils seems to address that need.

Do you look forward to doing more?

Well, if people commission me to, yes. I must admit that the reception that I've had suggests they weren't too impressed.

But that was only for one picture, wasn't it? For one particular job.

Well, I don't know. I've shown it to other people and their response has been fairly lukewarm as well, so maybe I'm in love with an idea that isn't really a practical career alternative. I don't know.

Maybe you're turning into a late rebel.

Perhaps I'm just fooling myself. Either that, or I'm not the best judge of the qualities in my own work.

You see that in other people, don't you? The work that you most admire of theirs is the work that they're most dismissive of.

Yes, and it makes it very difficult to make a selection of your own material for a book like this. You only have your feelings and instincts to follow, and sometimes they're very suspect. In my case, they can be influenced by all sorts of things. Like, when I went to Baltimore, I was influenced by the fact that almost everybody else there was working in these traditional methods – the guys who I admired were, certainly.

So you brought something away from that, and then incorporated it into your own agenda.

I just looked at it and, in my usual fashion, I said, 'Well, I can do this,' and set about doing it.

Above:
Robotic Bee
Acrylic on Crescent board
15x15ins (38x38cms)
Oxychem Corporation
1993

Right:
Robot
Acrylic on Crescent board
10x19ins (25x48cms)
Glaxo Drug Co.
Promotional material 1994

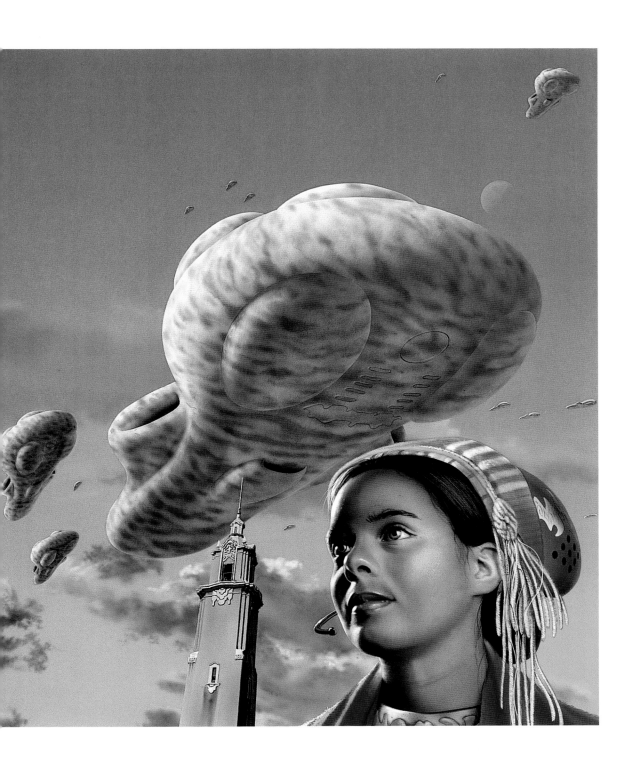

Left:
Our Friends From Frolix 8
Philip K. Dick
Acrylic on Crescent board
22x15ins (56x38cms)
Harper Collins
Wraparound cover 1997

We Can Build You

The background was based on a photograph of a church that I took in Florida when we were on holiday there in 1989. The foreground figure is a replicant, hence the input socket and serial number between her shoulderblades.

here's an argument as to whether art made to an editorial brief can ever be considered true art at all, and there are no easy answers to it.

Perhaps the last century's biggest legacy to art history has been the entrenchment of a division between fine art and commercial art. Fine art hangs in galleries and sells to the wealthy. Commercial art is ephemeral and belongs in the marketplace.

Yet it wasn't always so. The frescoes in the Sistine Chapel were painted to commission on a given subject (imagine it, the artist's worst nightmare . . . the Pope is your art director, and you can't argue with him because he's infallible). Most of the Old Masters were commercial artists as we'd recognize the term – they had clients, studios, assistants, schedules and deadlines. Some got rich and some went broke. Mostly they did well if they made a living by their skills.

Meanwhile, fine art in the 21st century is perceived as the exclusive province of the artist with Something to Say. Only fine art is free to be pure. Traditional skills can be irrelevant, even suspect. You can draw? How very quaint. Now watch me piss in this box.

ENDPIECE

But, clearly, it doesn't pay to be too rigid in our thinking. Not when the commercial art world throws up a hack like Rembrandt while the fine art scene brings us the genius of Yoko Ono. Roy Lichtenstein: when he copies a comic frame onto a giant canvas, is he showing up its banality with ironic brilliance or does he simply piggyback an element of Self onto the crude power of the original?

The fact is, I don't know. I can see both sides. And fortunately I don't see any requirement to commit to either. One of the most moving pieces of art that I ever experienced was a pile of rusty tin boxes in a Hamburg gallery. Monet's way with light on water makes my heart ache. On the walls of my house hang examples of the Trash Art of Belgian B-movie posters.

The important point here, I believe, is to exclude nothing.

Raymond Chandler once said that the aim of any artist should be to transcend the boundaries of genre. He was talking about writing, but the point has a wider application. Art with a capital A, in my experience, is something that steals into you while you're being otherwise entertained. The artist who merely entertains is . . . well, a mere entertainer; while the artist who sets out to be 'difficult' is getting by on the oxygen of indulgence.

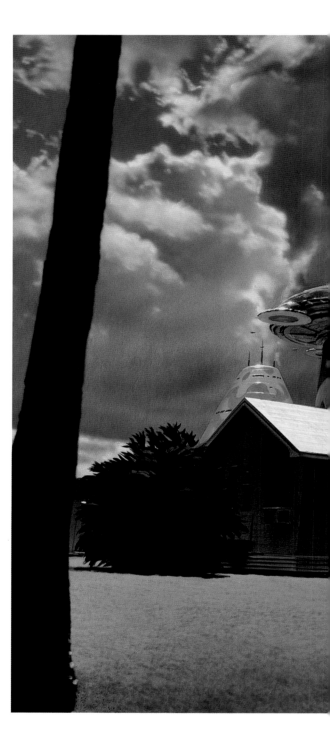

Right:
We Can Build You
Philip K. Dick
Acrylics on Crescent board
23x18ins (58x46cms)
Harper Collins
Wraparound book cover
1996

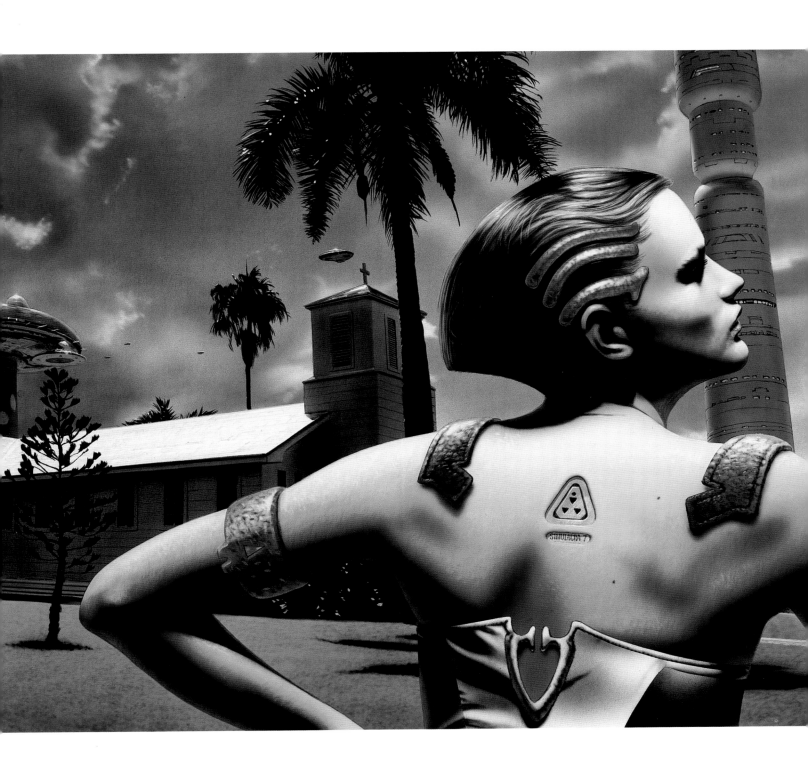

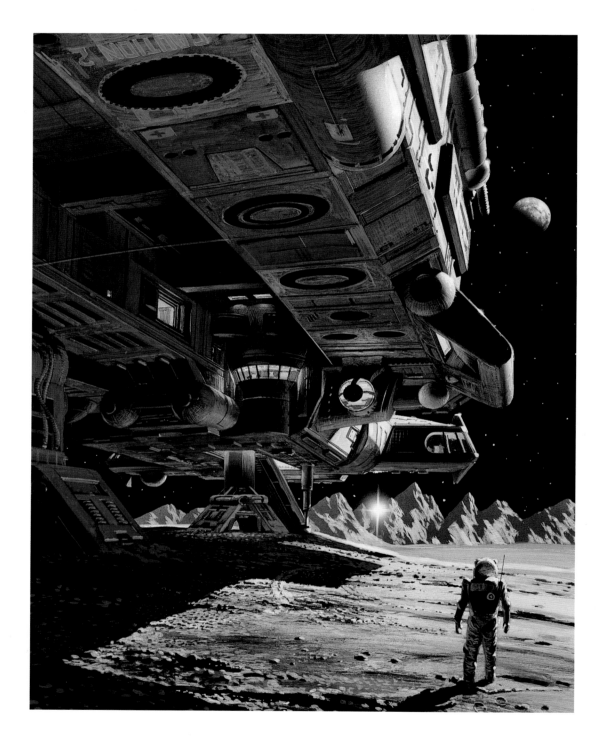

Right:
Sentinel
Arthur C. Clarke
Acrylic on Crescent board
10x15.5ins (26x39cms)
Grafton Books
Paperback cover 1986

The images in this book show an incredible level of technical skill, but at their best they go much further. When I pushed Chris to consider what he might see himself doing were he to follow his impulses outside a commercial environment, I thought his response was quite telling:

'If I didn't have to earn a living, I would do the science-fiction work all the time.'

For me, the significant mental image that I brought away from the interview sessions was of that unfinished painting of a space shuttle, standing on its tail above the stratosphere. A different medium, a different technique, a different process . . . but the same essence and intent that can be found in the main body of his other work.

In which case, it's no restriction for Chris to be working in a commercial environment. Fine art, commercial art, it makes no difference. What he's doing is exactly what he'd be doing anyway.

I'll tell you the most significant feature of a Chris Moore painting for me, and it concerns something that it doesn't have.

Book-cover art is hot stuff. It's desirable, it's collectable, and the best of it is seriously expensive. But take a lot of book-cover art out of its context, put it in a frame and let it stand alone, and for me it can seem to tell an incomplete story. Without the type and the text, it becomes a curio. It leaves me unsatisfied because I carry away a sense of missing information.

But then look at, for example, the series of Philip K. Dick covers commissioned from Chris by Orion towards the end of the nineties. For me they hold up as a brilliant series of stand-alone images: powerful individually, even more powerful if you group them together.

What's the thing they don't have?

They don't have that sense of dependency on missing elements.

When I raised this in our conversations, the artist's explanation was as pragmatic as ever. 'Since people started buying my paintings,' he said, 'there's been a slight change of emphasis in the way I compose them. I'll leave an area in the composition where they could put type, rather than deliberately create blank space so the picture doesn't work without it.'

Well, that may be so. But I suspect there's a little more to it.

I never wanted the text for this book to be the 'Chris Moore's art takes you beyond the wildest reaches of your imagination' type of eulogy. It's hard to keep flogging that kind of uncritical paean to book length and, I can tell you now, the writer would have tired of it even before the reader did.

What I've hoped to capture instead is a sense of the work, the life, the way it all is. I'm fascinated by the artistic process and, the further into it I go, the more convinced I become that all of the arts — whether it's music, painting, writing, whatever — share fundamental similarities. Creativity manifests itself in a certain way, and it follows certain patterns. The initial vision, the crude shaping, the steady process of refinement in the journey from broad strokes to fine detail . . . it's a sequence that applies as much to a symphony as to a poem or a sculpture.

I'm also fascinated by the life around the craft. If nothing else, this has been a great opportunity to poke and pry without a hint of shame.

OK. Now you know how it's done.

Time to go.

Below:
Discovery
Alkyd on masonite board
27x21ins (68x54cms)
Unfinished

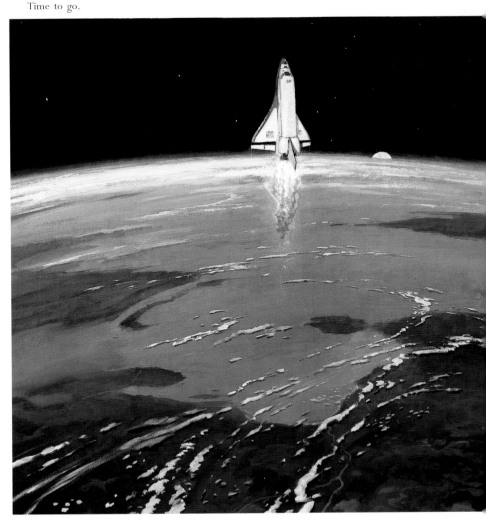

INDEX OF WORKS

Acknowledgements

Thanks to: firstly, Steve, for his enthusiasm and agreeing to do the book in the first place and to Marilyn, his wife for transcribing the interviews. My friends both past and present for their help and encouragement, to Dave and others for being there to pose at the drop of a hat, Pete Bennett for being so patient and for getting me started in SF.

To all the clients who have given me work over the last 28 years, Dom and Christine at AP, Francine and all at B&A, Fred Gambino for introducing me to the Curates Apple. All my artist friends for their inspiration and Jane and Howard Frank for making me feel valuable.

Right:
Great UFO Mysteries
Inks on Aram and Robinson
Line board
14x20ins (35x50cm)
Octopus Books
Cover 1982